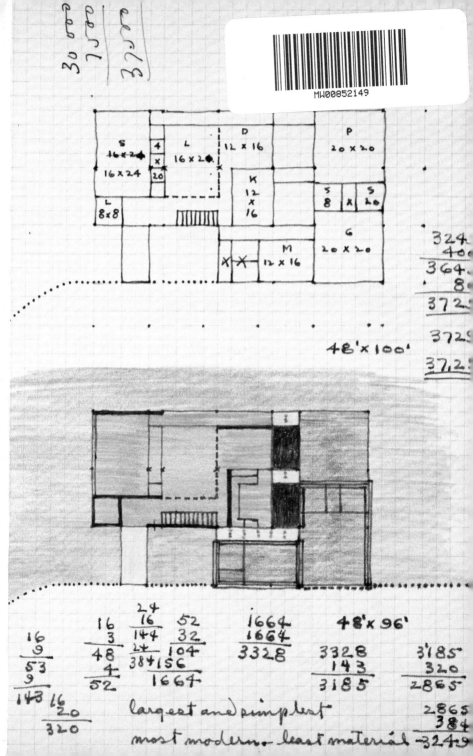

st Reason:
Smith,
Architecture

Against Reason:
Tony Smith,
Architecture, and
Other Modernisms
Volume 2

Editor
James Voorhies

2

Agair

Tony

and Other

Modernism

The MIT Press
Cambridge, Massachusetts
London, England

st Reason:
Smith,
Architecture

Against Reason:
Tony Smith,
Architecture, and
Other Modernisms
Volume 2

Editor
James Voorhies

With contributions by
Mario Gooden
Christopher Ketcham
Marta Kuzma
Peter L'Official
R. H. Quaytman
Jas Rault

2

© 2025 Tony Smith Foundation

Unless otherwise noted, all artwork by Tony Smith © Tony Smith Estate / Artists Rights Society (ARS), New York, NY. All other artwork © the artists or rights holders as noted in the photography credits. Texts and visual projects © the authors.

Unless otherwise noted, all materials cited in this volume are located in the Tony Smith Archives, New York.

All rights reserved. No part of this book may be used to train artificial intelligence systems or reproduced in any form by any electronic or mechanical means (including photocopying, recording, or information storage and retrieval) without permission in writing from the publisher.

The MIT Press would like to thank the anonymous peer reviewers who provided comments on drafts of this book. The generous work of academic experts is essential for establishing the authority and quality of our publications. We acknowledge with gratitude the contributions of these otherwise uncredited readers.

This book was set in Univers Next by Practise.

Printed and bound in Canada.

Library of Congress Cataloging-in-Publication Data is available.

ISBN: 978-0-262-55138-0

10 9 8 7 6 5 4 3 2 1

James Voorhies
Preface

History will always identify Tony Smith (1912–1980)—the American modernist whose large-scale works engage spectators phenomenologically, in shifting relation to motion, sightline, and perspective—as a sculptor. Yet Smith was also—and first—an architect. He practiced architecture for more than two decades before turning his attention full-time to sculpture in the early 1960s. His thinking on architecture, design, and urban planning, combined with early studies in mathematics, space, and volume, informed his work throughout his lifetime. Crucially, Tony Smith the sculptor cannot be considered apart from Tony Smith the architect.

Against Reason: Tony Smith, Architecture, and Other Modernisms looks at Smith's work as an architect through newly commissioned writings and visual arts projects by contemporary scholars, curators, and artists. Their own practices are expansive and, in some cases— like Smith's—multivalent and wide-ranging. Together, these explorations into the ongoing vitality of Smith's work pry into ingrained knowledge bases, exploring the canon of modernist thinking associated with Smith and widening disciplinary categories that have arisen from modernism's long-held imperative to order and classify.

In fact, this book is intended to break with convention, including with formats traditionally associated with the catalogue raisonné. As half of a dual publication project, *Against Reason* is a critical companion to the *Tony Smith Architecture Catalogue Raisonné*, which presents the full extent of Smith's identified production in architecture. Spanning his intellectual and creative pursuits in the field, the catalogue raisonné offers a complete record of his architectural output and is the most comprehensive documentation to date of Smith's

built and unbuilt works. These books devoted to architecture are part of the Tony Smith Catalogue Raisonné Project, which presents the depth of Smith's oeuvre in sculpture and architecture while positioning his transdisciplinary practice in dialogue with contemporary voices. This multifaceted publishing project seeks to innovate and update what a large-scale, long-term research effort can look and feel like, better reflecting the evolving methodologies for integrating research, thinking, and writing—indeed, interweaving modern and contemporary art histories.

With this impetus to take something known and read it anew, it is important to acknowledge that one of the most widely circulated accounts of Smith's work is his own: a recollection from the early 1950s—while he was a practicing architect—of a now iconic nighttime drive with his Cooper Union students on the unfinished New Jersey Turnpike. As the story goes, during this drive Smith had a profound revelation about art:

> **The road and much of the landscape was artificial, and yet it couldn't be called a work of art. On the other hand, it did something for me that art had never done. At first I didn't know what it was, but its effect was to liberate me from many of the views I had had about art. It seemed that there had been a reality there which had not had an expression in art.**[1]

Recollecting the event in a 1966 interview in *Artforum*, Smith told the curator Samuel Wagstaff Jr. (1921–1987), "The experience on the road was something mapped out but not socially recognized. I thought to myself, it ought to be clear that's the end of art. Most paintings look pretty pictorial after that. There is no way you can frame it, you just have to experience it."[2]

It may seem unusual to introduce Smith's architecture through a well-known anecdote related to his sculpture. Yet that is exactly what *Against Reason* aims for: to look at conventionally accepted knowledges through renewed perspectives, which allow readers to go deeper and look longer, to unpack and delve into accepted

understandings of Smith, the postwar era in which he developed, and discourses through which his work was originally read. The turnpike story has been primarily interpreted through the lens of Smith's sculpture. But the experience he describes—from the early 1950s—happened ten years prior to his turning to sculpture. He was still working as an architect, having finished several commissions while taking smaller exhibition design projects for such clients as gallerist and artist Betty Parsons (1900–1982). Although he would eventually cease to practice architecture formally, there was no definitive break from *thinking* architecture. Design would continue to influence his work across the board, even as he committed to making sculpture by the early 1960s.

The New Jersey Turnpike anecdote underscores Smith's preoccupation with scale, the relationship between the built environment and humanity. What Smith vividly recalled was driving at night on that vast expanse of new asphalt, moving through an unmarked landscape. The smooth, undulating, seemingly endless surface amplified the relationship between human scale and the human-built environment. For Smith, the experience was sublime. His fascination with the geometrical forms found in his architecture would eventually be transposed to sculpture, yet these early observations on scale, volume, and dimension—monumentality— are keys to his thinking on architecture.

Smith's initial forays into design were influenced by his studies in 1937–38 at the New Bauhaus in Chicago with noted instructors Alexander Archipenko (1887–1964), Hin Bredendieck (1904–1995), György Kepes (1906–2001), Henry Holmes Smith (1909–1986), and László Moholy-Nagy (1895–1946), who led the program, followed by a busy year serving as clerk of the works on Frank Lloyd Wright's (1867–1959) residential project in Ardmore, Pennsylvania, then attending Wright's Taliesin Fellowship in Green Spring, Wisconsin, in 1939. The style of Smith's early houses mirrors both the form and content of Wright's architecture. In 1940, in Blacklick, Ohio (just outside Columbus), the twenty-seven-year-old Smith designed and built his first house along with the nineteen-year-old architects Theodore van Fossen and Laurence

Cuneo, whom Smith had met at the New Bauhaus. In this house for Robert and Mary Gunning, the young architects employed Wright's Usonian principles: an open plan, carport, storage walls, solar heating, radiant heat, and a structure long and low to the ground, with a thin overhanging roof and narrow windows. In 1944, Smith designed and built a house for his father-in-law, L. L. Brotherton, in Mount Vernon, Washington. The design of the Brotherton House uses a hexagonal grid as the primary planning device, visible in ground-plan drawings for the 3,500-square-foot house and in finished diagonals that populate the interior. Smith's geometric design recalls Wright's references to molecular cell structures like the beehive, signaling some of Smith's conceptual and compositional underpinnings and motivations, and using geometric forms as foundational building blocks that would become so critical to his later sculptures.

By the mid-1950s, as an independent architect, Smith had dispensed with Wright's organicism, partially as a response to living in Germany and traveling through Europe, exchanging it for the formal principles of European modernism and the reductivist steel-and-glass structures characteristic of the work of Ludwig Mies van der Rohe (1886–1969) and Le Corbusier (1887–1965). Smith would merge the rationalism of the International Style with his enduring interest in the organic cohesion of modular forms. He would continue to consider the conditions of place as mediating between natural elements and abstract geometries, in designing mostly private residences but also churches, public housing, visionary urban planning projects, and artist studios. Smith's Olsen Sr. House consists of four buildings, three of which sit atop a cliff overlooking Long Island Sound, in Guilford, Connecticut. The influence of Le Corbusier is evident in Smith's use of *pilotis* (piers), comparable to those seen in Corbu's Villa Savoye in Poissy-sur-Seine, France, or the Carpenter Center for the Visual Arts in Cambridge, Massachusetts. Other references to Le Corbusier and even to Philip Johnson (1906–2005), whose Glass House was completed in New Canaan, Connecticut, in 1949, are notable in the Olsen Sr. House, including the expansive open courtyard, large plate-glass windows, and spatial transitions and manipulation of geometries that would later characterize Smith's sculpture.

Smith's architectural projects were relatively unknown to the public at the time, though a few received publicity because of the art world clients who commissioned them, and a handful of others have been subsequently studied. Some of the building projects originated from a circle of friends in the visual arts and theater scenes. In 1943, Smith married the opera singer and actress Jane Lawrence (née Brotherton) who was friends with the playwright Tennessee Williams (1911–1983) and the artist Fritz Bultman (1919–1985). In fact, Smith's immediate network included such luminaries as Hans Hofmann (1880–1966), Buffie Johnson (1912–2006), Barnett Newman (1905–1970), Jackson Pollock (1912–1956), Mark Rothko (1903–1970), Anne Ryan (1889–1954), and Clyfford Still (1904–1980), among others. Smith built a painting studio in 1945 for Bultman in Provincetown, Massachusetts. In 1950, he collaborated with Pollock on an unrealized design for a Roman Catholic church. The next year, he designed and built a house for the painter Theodoros Stamos (1922–1997) in East Marion, New York. In 1952, he designed and built a house for Orlando and Barbara Scoppettone in Irvington, New York, a kind of transitional design responsive to the topography and landscape while breaking with Usonian principles in his use of wood piers and glass. Around the same time, he began work on the above-mentioned house in Guilford, Connecticut, for the art collectors Fred and Florence Olsen, with spaces especially conceived to display their art collection, which included Pollock's famous 1952 painting *Blue Poles*. He designed Newman's solo exhibition at the gallery French & Co. in 1959, exhibitions for the Betty Parsons Gallery, and eventually a studio (1960) and guest house (1961–63) for the artist/gallerist Parsons—both in Southold, New York, on Long Island's North Fork. Indeed, Smith maintained a large network of close friends and colleagues, associations that provided him with a valuable outlet for experimentation and collaboration, leaving behind a rich body of architectural designs and urban planning projects—many of which have not been known to the public until now.

The contributions to this book and the work presented in the catalogue raisonné demonstrate the extraordinary complexity of

Smith's thinking about design. His built works were only a fraction of an oeuvre deeply engaged with intellectual and creative questions around space and differences between the built environment, nature, and humanity—most indelibly, with the issue of scale. It is true that Smith's ruminations about asphalt, and his marked reservations about art's ability to fulfill its responsibility to represent, are part of the story of Tony Smith the sculptor. Yet, as the contributors in the following pages profoundly show, Smith was always thinking in and through concepts of architecture.

To arrive there, Mario Gooden's essay "In-Between Reason: Tony Smith's Transmutation of Space Architecture and Sculpture" serves as a grounding reflection on Smith's decades-long interests and commitment to thinking through the intersections of geometry and mathematics in his work. This essay continues the line of thought Gooden introduced in the first volume of *Against Reason*, wherein an aesthetics of Smith's work—whether in architecture, sculpture, or writing—is detectable in the liminal, or in-betweenness; for example, in how the different open floor plans of Smith's architecture refute the expected functionality or performance of *kitchen*, *dining room*, or *living room*. Here, Gooden walks readers through various case studies—from Smith's design sketches for the unbuilt Untitled (hexagon house) to the majestic Olsen Sr. House in Guilford—to explore Smith's deeply intellectual engagement with mathematics, geometry, and place that ultimately countered the logical reason embedded in those scientific disciplines.

Peter L'Official, in his essay "Outsider Art: Hawai'i, *Haole Crater*, and Tony Smith," considers an offhand, seemingly insignificant, and yet ultimately impactful exchange Smith had with a Japanese American student in 1969, when Smith taught summer school at the University of Hawai'i at Mānoa. From this revealing point of departure unfurls an analysis of Smith's sculpture in the contexts of Indigenous practices, decolonizing methodologies, and Smith's sensitivity toward place, space, and site, the breadth of Smith's thinking demonstrated by revisiting other aspects of his design work. L'Official reads two unrealized site-specific works by Smith—the massive *Haole Crater* (1969) proposed for the university

James Voorhies

campus in Honolulu; and *Mountain Piece* (1968), a proposal to radically transform the topography of Round Mountain in Valencia, California—through lenses of Indigeneity, colonialism, and contemporary critical discourse. L'Official homes in on the sensitivity Smith applied to thinking about site—not only as a physical thing but as something intertwined with complex social and political histories. Through his study of these two cases, L'Official shows how Smith's interests in space and the built environment, which originated in his early years practicing architecture and urban planning, continued to inform his thinking and work throughout his life.

In his essay "A Valid Confrontation: Tony Smith and the Sociogeometries of Urban Space," Christopher Ketcham reasons how theories of urban space were central to Smith's practice, whether working on architecture, sculpture, painting, or writing. The shape of the square serves as the entry point for Ketcham's account of Smith's 1970 proposal for urban renewal in Minneapolis by completely paving a city block with granite—and nothing else—to create a stage for the theater of urban life. This *Project for a Parking Lot* was ultimately rejected. Although Smith's fame as a sculptor may well have been at its zenith at this moment, Ketcham demonstrates how Smith's thinking remained tethered to his study of urban planning in the 1940s and '50s, while he was working as an architect. He also points to the groundbreaking 1967 exhibition of Smith's sculptures in New York City's Bryant Park—another kind of town plaza—as a municipal campaign to reclaim the city from certain "undesirable" publics, namely, gays and the unhoused. The unearthed potential Smith may have seen in a plaza, city park, or parking lot paradoxically ran counter to administrative attempts to eradicate nonnormative behavior in order, as Ketcham states, to "return to the nineteenth-century pastoral spaces in the city."

In "Tony Smith's Queer Architectures: 'the inscrutability and the mysteriousness of the thing,'" Jas Rault acknowledges at the beginning of her essay that Tony Smith is not often included in histories of queer art and architecture. Yet, as she notes, "His life and work were strikingly bound up with an inordinate number of queers," reminding readers that at least four of the ten buildings

Smith completed were designed for queers: the studio for Fritz Bultman, house for Theodoros Stamos, and studio and guest house for Betty Parsons. Rault's close study of the archival materials related to these buildings offers readings of their interior and exterior spaces and floor plans, along with pertinent postwar histories of sexual identity and suburban development. Around the years Smith built these structures, nearby on Long Island tracts of suburban modular homes were being constructed "to house the postwar push to segregated white heterosexual reproduction." Nevertheless, as Rault articulates, Smith's designs for Bultman, Parsons, and Stamos were untethered from conventional designs of domestication put forward in the heteronormative architecture of the family home, and bonded to prescriptive behaviors of heterosexuality. Rault guides readers through an astute analysis of Smith's choices about the organization of spaces and the ways bodies might inhabit his interiors. He would succeed in meeting the expectations of his queer clients who, as Rault suggests, sought a remove from the postwar demands of how to be and behave, of performing heterosexuality, finding refuge in country houses and studios shared with others.

Conditions of place—whether social, geographical, or even geological—are the basis for visual and written contributions by Marta Kuzma and R. H. Quaytman. Centered on Smith's house for the art collectors Fred and Florence Olsen, "The Olsen House, Old Quarry, Guilford, Connecticut" documents the design, construction, and eventual habitation of this residential complex, interlacing reproductions of drawings and illustrations by Smith with facsimiles of documents and letters. The work is interrupted by an archival collection of images and text, "My Home: A Pentagon," compiled and written by Quaytman, an artist who has lived in the Olsen house since 1999. Her telling of the history of the house combines with the story of her purchase of the property and life there, punctuated with photographic slides by the original owners as well as her personal photographs of friends and family, revealing the social life of the Olsen House spanning over half a century.

Against Reason: Tony Smith, Architecture, and Other Modernisms introduces unknown architectural projects by Smith—most never

before discussed—while offering new lenses through which to read the handful of projects that are known to the public. For artists, curators, and writers—and specialist readers and researchers who will benefit from the *Tony Smith Architecture Catalogue Raisonné*, with its commentary and documentation on more than ten built projects and over a hundred unbuilt works—this dual publication offers expansive insights into modernism's ongoing influence and the enduring impact of one of its most important practitioners.

1 Tony Smith, quoted in Samuel Wagstaff Jr., "Talking with Tony Smith," *Artforum* 5, no. 4 (December 1966): 19.

2 Wagstaff, "Talking with Tony Smith," 19.

Mario Gooden

In-Between Reason: Tony Smith's Transmutation of Space Architecture and Sculpture

In his book *Il Saggiatore* (*The Assayer*, 1623), Galileo Galilei (1564–1642) — the central figure of the scientific revolution of the seventeenth century, whose discoveries in astronomy and physics substantiate subsequent concepts of time and space — made the pronouncement that the "grand book of the universe [nature] is written in the language of mathematics, and its characters are triangles, circles, and other geometric figures without which it is humanly impossible to understand a single word of it; without these, one wanders about in a dark labyrinth."[1] Galileo's statement and specific reference to "the universe" situate mathematics within the relational conditions of space and time as changing and dynamic, based upon his observations of the cosmos and movements of celestial bodies. Mathematics can be understood, therefore, not as static or fixed but rather as sets of relationships among points in movement that can be described in the proximate terms of nearness, closeness, continuity, convergence, and in-betweenness.

Similarly, the ingenious baroque architect Francesco Borromini (1599–1667) conceived of the entirety of his building designs in terms of mathematics. As discussed by noted British art historian Sir Anthony Blunt, direct evidence confirming Borromini's conceptualization of mathematics and his interest in the relational conditions of the *universe* can be found in Borromini's letter to Cardinal Camillo Pamphili (1622–1666) explaining his designs for a villa for the cardinal in Rome. In this letter, Borromini explains that the building would have thirty-two windows arranged such that lines drawn to them from the center point of the structure would correspond to the thirty-two compass points representing the thirty-two winds. Four other points in the building would be connected by lines representing the tropics of Cancer and Capricorn. According to Borromini, "In fact the whole building would be a study in applied mathematics."[2]

As an admirer of Michelangelo, Borromini worked within the rules of the ancients while simultaneously using mathematics and geometry to stretch, bend, and test their limits, often resulting in an in-betweenness of constant spatial movement, dynamism, and fluctuation. In his design for the church of Sant'Ivo alla Sapienza in Rome, Borromini reworked the initial proposal by Giacomo della Porta (1532–1602) of a circular chapel inscribed in a square, basing his parti on a hexagon inscribed in a circle. To this, Borromini added three semicircles whose center points are the midpoints of three sides of the hexagon. Borromini then extended the sides of the hexagon to create an equilateral triangle whose apices locate the center points for three niche altars, or aediculae.[3] The result is a mysterious spatial fluctuation between the hexagon and the circle that is perspectivally intensified by the triangulated relationship of convex and concave aediculae. Furthermore, the entire composition is set in a continuous, undulating circular motion by the entablature at the top of the columns and pilasters, the articulation of the second-story rails, and the continuous column base around the perimeter of the interior. Borromini's design reveals the plasticity of architectural space through the topological transmutation of geometry and mathematics that results in conditions of liminality in between rationality and irrationality.

Mario Gooden

Tony Smith's architectural designs and sculpture seek a similar Borrominiesque topological transmutation of geometry and mathematics to reveal the mysteriousness of space and spatial relationships existing between the conscious and unconscious, the rational and irrational, reason and intuition. In his introductory essay for the catalogue to the 1988 exhibition *Tony Smith: Architect, Painter, Sculpture*, at the Museum of Modern Art in New York, curator and art historian Robert Storr notes that, for Smith, textbook geometry alone was lifeless; however, mathematics remained the key for Smith to unlocking the mysteries of dynamic form.[4] Smith's obsession with the hexagon and its fluctuations back and forth from two-dimensional plane geometry to complex three-dimensional cubic and apparitional decagon volumes is a trajectory that extends over decades, from his 1944 design for the L. L. Brotherton House to *Smoke* (1967), and ricochets backward to illuminate the slippages, liminalities, and particular uncanniness of his architectural designs.

During the summer and fall of 1966, leading up to his first solo exhibition, *Tony Smith: Two Exhibitions of Sculpture* — shown simultaneously at the Wadsworth Atheneum Museum of Art in Hartford, Connecticut, and the Institute of Contemporary Art in Philadelphia — Tony Smith stated in a conversation with Samuel Wagstaff Jr. that his interest in geometry and the organizational structures of polyhedra began in his formative years:

> I had been familiar with the root rectangles of Jay Hambidge's "Dynamic Symmetry" since before I started high school. I had had no experience in architecture, and the notion of planning according to regular bays, although all over the place, hadn't occurred to me. . . . Meanwhile I had been interested in the exposition of close-packing in D'Arcy Thompson's "On Grown and Form." . . . Thompson was writing about the effects of mathematical and physical laws upon living form.[5]

While the major achievement of Thompson's *On Growth and Form* lies in its analyses of organic processes and their mathematical properties, for Smith, Thompson's concepts and theories were a foundational illustration of his own philosophical position expressed in "The Pattern of Organic Life in America," an expansive manifesto written while he lived in California in 1943–45:

America—I am trying to clarify the pattern of organic life in America. I think that there is such a pattern here and it only needs uncovering. The poets have seen it, Thoreau, Whitman, Wright; but no one else has much idea of it. . . .

The Western World is in every dimension bilateral symmetry, applied order, formal, arbitrary, static. They do an essentially material thing like putting four legs on a chair and then hang on some style. The style of organic

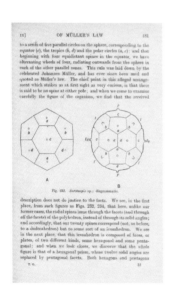

Diagrammatic structure of the skeleton of *Dorataspis* (fig. 232), in D'Arcy Wentworth Thompson, *On Growth and Form*, ed. John Tyler Bonner (1917; Cambridge: Cambridge University Press, 1942), 481

Tony Smith, Untitled, ca. 1950, graphite on
tracing paper, 17¾ × 18¼ in. (45.1 × 46.4 cm)

life is intrinsic; it is built in, as it is in the airplane. Here in
America, in the New World, style is conceived as built in, not
hung on. Instead of the Cross we follow the law of growth,
the spiral, dynamic equilibrium. . . . Only in our magic, our
puritanism, in our Freudian and colonial little boxes are we
formal and false. Puritanism channeled in terms of growth
as in Thoreau, as in Juan Gris gives an intense and vibrant
life—but we just beat ourselves with it.[6]

However, Thompson's theory of organic "cell-aggregates"
and "close-packing" was not only informative to Smith's meta-
physical, nationalistic, and spiritual goals; Smith would also extract
Thompson's theorization of hexagonal geometry as an inherently
organic form. In his illustrations for the single-celled Radiolaria in
On Growth and Form, Thompson states that their organic form is
an icosahedron "composed of faces, or plates, of two different kinds,

some hexagonal and some pentagonal; and when we look closer, we discover that the whole figure is that of a hexagonal prism. . . . The true symmetry of this figure, then, is hexagonal, with a polar axis, produced into two polar spicules; with six equatorial spicules, or rays, and with two sets of six specular rays, interposed between the polar axis and the equatorial rays, and alternating in position with the latter."[7] A strikingly obvious example of the literalness of this application is Smith's design for a hexagon-shaped house (Untitled, ca. 1950), which appropriates Thompson's structural diagram of *Dorataspis* for the spatial disposition of everyday living spaces surrounding a central core containing two bathrooms and a fireplace.

In what appears to be the design's first preliminary floor plan drawing, Smith situates the fireplace symmetrically at the centerline of the hexagon. However, the symmetry of the floor plan is thrown into question by the circulation to the bedrooms and access to the bathrooms that induce a centripetal movement in an otherwise static

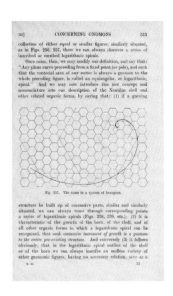

System of hexagons demonstrating the logarithmic spiral, in D'Arcy Wentworth Thompson, *On Growth and Form*, ed. John Tyler Bonner (1917; Cambridge: Cambridge University Press, 1942), 513

Mario Gooden

plan. In a slightly more developed drawing of the floor plan, Smith exploits an inscribed equilateral triangle to asymmetrically shift the fireplace and bathrooms to create an en suite bathroom and discreet circulation to the bedrooms. A number of penciled overlayed walls and lines create fluctuations in the drawing that attest to Smith's attempts not to resolve the geometry but rather to further exploit the ambiguities and in-betweenness of the domestic spaces that will flow one into the other—kitchen, dining room, and living room.

Yet Thompson's theorization of hexagonal geometry actually begins with the consideration of multicell structures. In the chapter "The Forms of Tissues, or Cell-Aggregates," Thompson explains that the mutual interaction of polyhedral cells, when under conditions of uniform and symmetrical pressure, results in regular hexagons. This result is illustrated in the morphogenic effects of the diffusion experiments of French biologist Stéphane Leduc (1853–1939).[8]

Finally, Thompson demonstrates that a system of hexagons also relates to the logarithmic spiral (commonly understood in the form of the nautilus shell) resulting in nested and overlapping geometries. Although Smith's use of the hexagon in the design for the Brotherton House (1944–45) in Mount Vernon, Washington, bears a conspicuous resemblance to Frank Lloyd Wright's hexagonally gridded floor plan for the Hanna House (also known as the Hanna-Honeycomb House, Palo Alto, California, 1936), Smith initially organizes the Brotherton House along intersecting diagonal axes. In contrast to the Hanna House floor plan of clearly delineated spaces organized in linear clusters along a main spine, Smith's use of the hexagonal grid results in overlaps, slippages, and spatial elisions, producing programmatic in-betweenness and domestic liminalities in an open floor plan of flow and fluctuation. Minimal interior walls and few if any doors, even in the semiprivate as well as private spaces of the house, heighten the sense of ambiguity and mystery.

An early concept sketch drawn in red pencil on the back side of a South Orange Trust Company bank deposit receipt, dated May 29, 1943, exhibits Smith's intention for this design for Brotherton, his father-in-law. The kitchen, dining room, living room, study, and foyer unfold and undulate around the intersecting point of the two

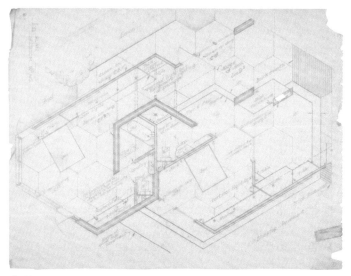

Smith van Fossen, *L. L. Brotherton House*, 1944–45, graphite on tracing paper, 17⅝ × 23½ in. (44.8 × 59.7 cm)

diagonal axes forming an X-shaped parti. Although the floor plan of the final design would resemble a Y-shape rather than the original X-shape, the general organization remains intact, with the intersection of the cross axes doubly signified by the back-to-back elements of a spiral stair as a solid volume and the fireplace as a void.

Smith's drawings for the Brotherton House foreshadow many of his sculptural works of the 1960s. Yet the trajectory is a through line of mathematical operations of movement, mutability, and liminality that exist in the mysterious slippage between the known and the unknown. Further explaining his interest in geometry and mathematics in the 1966 conversation with Wagstaff, Smith stated, "I'm very interested in Topology, the mathematics of surfaces, Euclidian geometry, line and plane relationships. 'Rubber sheet geometry,' where facts are more primary than distances and angles, is more elemental but more sophisticated than plane geometry." Continuing, he declared, "I'm interested in the inscrutability and the mysteriousness of the thing. Something obvious on the face of it . . . is of no further interest."[9]

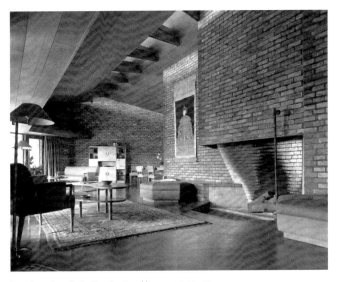

Interior view, L. L. Brotherton House, 1944–45,
Mount Vernon, WA, 1948

An enlarged drawing on tracing paper of the bedroom wing for
the Brotherton House provides clues to Smith's interest in the trans-
mutation of geometry, mathematics, and the topological conditions
that would lead to his sculptural practice. While the drawing is labeled
"Floor Plan," the elements of the sketch visually shudder between
two dimensions and a three-dimensional isometric projection. By
definition, an isometric projection is a drawing of a three-dimensional
volume in which the horizontal lines of the volume are set at thirty
degrees to a perpendicular vertical line along the edge or corner of the
volume. In the overall design of the Brotherton House, Smith rotated
the hexagonal grid ninety degrees such that the base of any hexagon
is at thirty degrees to a horizontal line. The result of the rotation is that
the six-sided shape reads as a hexagon in plan and simultaneously as
an abstracted cube in isometric projection. The uncanniness of this
sleight of hand renders the guest bathroom and the master bedroom
bathroom in the drawing as if they comprise a cubic volume forming
the core of the bedroom wing. Additionally, the exterior walls of the

bedroom wing are drawn to elicit the in-betweenness of two and three dimensions. The drawing is made all the more suspicious by Smith's designs for the doors and windows, their frames and mullions at thirty-degree angles askew rather than perpendicular to the walls. Finally, the most astounding and surprising aspects of the drawing are the notes and labels, all of which are hand-lettered at a thirty-degree diagonal rather than horizontal, which is normative and legible for an architectural floor plan. Hence the mechanics of the drawing, as well as its representations and spatial concepts, slip back and forth between the rational and the irrational, and point the future trajectory of Smith's practice wherein the transmutation between hexagon and cube would remain an obsession.

In a critique of the polar extremes in architectural theory between the forced dualities of the modern movement and the historicism of post-modernism in the 1980s, architect and writer Fred Koetter theorizes the notion of the in-between and the liminal as a zone that may be the most radical. "This in-between condition, difficult though it may be to describe, could, in its aloofness, have a closer relationship to an 'actual condition of reality'—compounded, multifarious, slippery, uncertain, hard to define in both theory and practice—than any fixed point of interest could allow."[10] Koetter acknowledges the liminalities in the works of another architect and sculptor, Michelangelo. In particular, he references Michelangelo's design for the entry vestibule (also known as the *ricetto*) at the Laurentian Library in Florence, Italy.

> Here, genuine structural columns, set in niches, and supporting a broken entablature, are made to appear eminently non-structural—as almost free-standing pieces of detachable sculpture. By way of this oft-noted contrivance, Michelangelo was perhaps saying something about the nature of assumed absolutes . . . that gravity itself is not beyond speculative interpretation. Likewise, the overall effect of the vestibule wall is one of serious disjunction—

of a colossally scaled public wall deployed to define a physically small, intimate interior space. The effect is not only overwhelming, but fundamentally inexplicable.[11]

Koetter theorizes, "The 'in-between' is also then the realm of conscious and unconscious speculation and questioning—the 'zone' where things concrete and ideas are intermingled, taken apart and reassembled—where memory, values and intentions collide. And the pedagogical implications, for instance, of this transaction would seem obvious."[12] Borromini, who considered himself to be the heir to Michelangelo and who understood his plastic treatment of space, states in his opening letter to the reader in his *Opus architectonicum Equitis Francisci Boromini*, "And when sometimes I appear to have gone out of the ordinary in designs, I beg them to remember what Michelangelo the prince of architects said: that he who follows others never goes before them."[13] Borromini states that his intention is to invent new things. Thus, Tony Smith's architecture and sculpture are in a line of invention that extends from Michelangelo through Borromini in his transmutation of geometry and mathematics to produce liminality and invent new understandings of architectural space.

In the years following the design of the Brotherton House, Smith continued to experiment with hexagonal and polyhedral geometries and their liminal possibilities, first in such projects as the Fritz Bultman Studio (Provincetown, Massachusetts, 1945), whose initial sketch illustrated a polyhedral volume inscribed within a rotated rectangular roof form. Next, the unrealized design for a Roman Catholic church (1950) with painted glass windows by Jackson Pollock harked back to D'Arcy Wentworth Thompson's diagram of hexagonal cells, illustrations of radiolarians, and concepts of cell aggregates and close packing, with twelve polyhedral volumes clustered and raised above the ground, supported by spicule-like pilotis. Smith's perhaps best-known architectural project, the 1951 house for painter Theodoros Stamos (1922–1997), in East Marion, New York, is simultaneously a square in plan, double hexagonal shapes on the north and south elevations, and a hexahedral volume in section—also raised above the ground and supported by pilotis, recalling Smith's design for the church.

Finally, in the design for the Fred Olsen Sr. House (1951–53), in Guilford, Connecticut, his most ambitious residential architectural project, Smith does not experiment with the mutation of the hexagon and the cube but rather derives complexity and ambiguity from the relationship between the pentagon and the circle. The design refers not to D'Arcy Wentworth Thompson but to Jay Hambidge's *Elements of Dynamic Symmetry*, originally published starting in 1919 as a series of lessons in the Yale journal *The Diagonal*, which explored the law of natural design based upon the symmetry of growth in humans and plants. In Lesson IV, Hambidge describes the different proportions, ratios, and reciprocal values derived from the relationship of the polygon within a circle.[14]

Designed for a site on a rocky cliff overlooking Long Island Sound, the overall master plan for the set of three structures is achieved by offsetting the initial circle five times to create compression and expression on the site, and then by offsetting the east, south, and west edges of the pentagon multiple times to create the

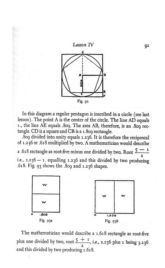

Jay Hambidge, Lesson IV, in *The Elements of Dynamic Symmetry* (New York: Dover Publications, 1926), 91

Mario Gooden

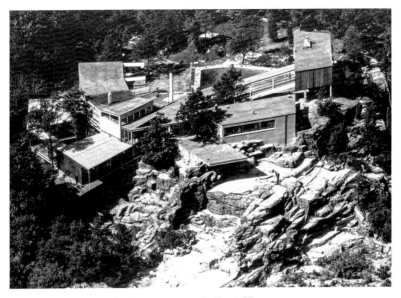

Aerial view, Fred Olsen Sr. House, 1951–53, Guilford, CT

exterior circulation zones and interior transition spaces at the main house and guest house. From these relationships, Smith derives trapezoidal shapes for the patio, main house, and guest house. Finally, he derives the shape of the swimming pool from an offset circle in relationship to the site topography and uses the pool to set the entire composition into a dynamic centrifugal rotation that locates the curved artist's studio along the western edge of the original circle while thrusting the trapezoidal patio into a cantilever over the cliff. The overall movement of the composition is much more dynamic than any of Smith's previous designs, and he completes this choreography of movement with additional minor and major spatial operations. The exterior spiral stair at the north edge of the studio not only connects the carport below to the patio above but is also a device that hinges the composition from plan to section, whereby a perspectival section view of the assemblage rotates the curved shape of the studio from its floor plan to its roof. A flood-light tower at the intersection of the patio and the ramped walkway

becomes the pivot point that induces a curved movement to the walkway that had originally been conceived of as a straight east-west path along the north elevation of the main house. This movement mediates the two-dimensional to three-dimensional relationships of the design and puts the overall design and experience of the house in suspended liminality.

While the origin of Smith's design may be predicated upon absolute geometries and mathematical relationships, the generated movement that slips between two and three dimensions at the Olsen House, as well as the zones of transition and movements that oscillate in the offset of planimetric geometries, result in the inscrutable conditions of the in-between that defy the binary division of rational versus irrational, or reason versus intuition. Unfortunately, Tony Smith is said to have been frustrated by his experiences with the completion of the Olsen House. Robert Storr notes that "construction problems, the orientation of the building in relation to prevailing winds, and other difficulties plagued the houses from the outset, and unwanted concessions required of Smith subsequently compounded by unwelcome alterations by the owner distorted the architect's scheme for the senior Olsen's house."[15] Smith completed only one more significant architectural project—a Studio (1960) and Guest House (1961–63) for artist, gallerist, and friend Betty Parsons, in Southold, New York—before making a full pivot toward his sculptural practice in the 1960s. While the buildings are notable for their apparent retreat from the organic geometries of Thompson or the dynamic symmetries of Hambidge, in favor of orthogonal modernism, the interior stair of the Parsons studio is externally expressed as a sculptural fragment of a Platonic polygonal volume that foreshadows many of Smith's sculptures from the 1960s onward.

Yet Tony Smith never abandoned his obsessions with the transmutability of geometry and mathematics. In a series of drawing experiments from 1960–65, he considers the plasticity and liminalities of various polyhedral volumes and forms. The first of these is a set

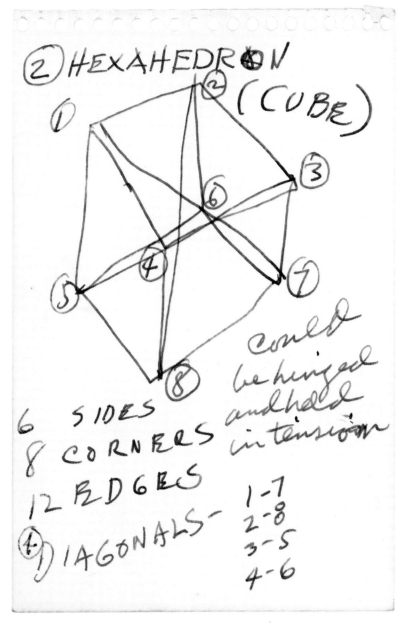

② HEXAHEDRON (CUBE)

6 SIDES
8 CORNERS
12 EDGES

could be hinged and held in tension

④ DIAGONALS –

1-7
2-8
3-5
4-6

Tony Smith, sketches, ca. 1960s, ink on paper,
each page 6 × 4 in. (16.24 × 10.16 cm)

(3) OCTA HEDRON

8 - SIDED
12 - EDGES
6 - VERTICES

3 INTER-
SECTING
SQUARS ON
THE DIA-
GONAL -
THE DIA-
GONALS
OF THESE
SQUARES

AGAIN - HINGED AT CENTER

④ REGULAR DODECAHEDRON

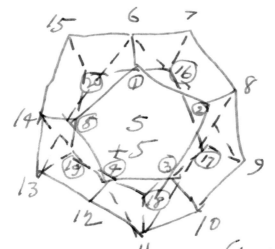

12 - SIDES
30 - EDGES
20 - VERTICES

1 - 18
2 - 19
3 - 20
4 - 16
5 - 17

6 - 11
7 - 12
8 - 13
9 - 14 10 - 15

④ – Ⅱ REGULAR DODECAHEDRON

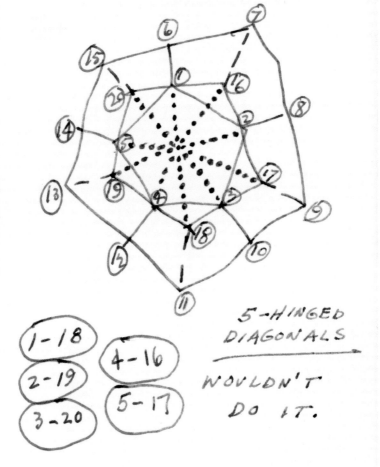

5-HINGED DIAGONALS

WOULDN'T DO IT.

1-18
2-19
3-20
4-16
5-17

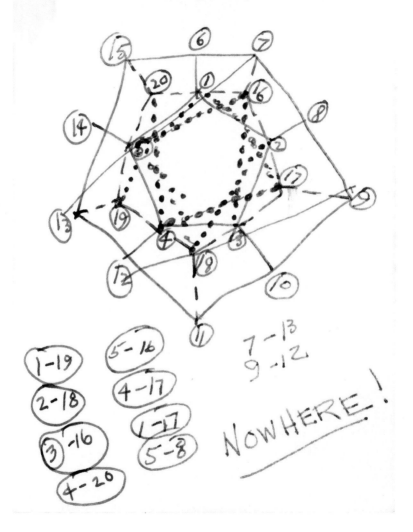

REGULAR
DODECAHEDRON

1-19
2-18
3-16
4-20

5-16
4-17
1-17
5-8

7-13
9-12

NOWHERE!

of sketches drawn in blue ink in a small, spiral-bound sketchpad. In one sketch, Smith attempts a transmutation between a hexagon and a cube (technically a regular hexahedron). Smith notes around the sketch that the volume should have six sides, eight corners, twelve edges, and four diagonals. In accordance with the properties of Euclidean geometry, the proposition is both impossible and mathematically irrational, for the ratio of four to six results in an irrational number whose value approaches infinity. Yet Smith does not attempt to collapse the volume into a stable shape. Rather, his experiment describes a volume or an inhabitable space in an ambiguous and fluid state that slips back and forth between certainty and uncertainty, legibility and illegibility, the rational and the irrational. Furthermore, Smith suggests that this transmutation can be achieved by hinging the sides and holding them in tension. This sketch returns to the conceptual questions first investigated in the Brotherton House and illustrated in the enlarged drawing of its bedroom wing.

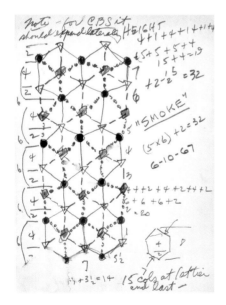

Tony Smith, *Smoke*, 1967, ink on paper,
12 × 9 in. (30.5 × 22.9 cm)

Mario Gooden

The next sketch experiments with the transmutation between an octahedron and three intersecting squares that imply a cubic volume. Again, Smith notes on the sketch that this could be achieved by hinging at the center. The remaining three sketches in the set experiment with iterations of the extremely complex geometry of a dodecahedron. Smith notes an air of exhaustion with his goal for this experiment on the final sketched iteration, exclaiming, "Nowhere!" Therefore, what might be taken initially as a set of sculptural speculations were, in fact, architectural speculations about liminality and in-betweenness.

In a second significant drawing experiment from this period, Smith plays out a series of movements that begin with a fragment that is simultaneously a tetrahedron in elevation, two sides of a hexagon in plan, and/or a vertical side of a cube in an isometric projection. Drawn in black and red ink on quarter-inch graph paper, the figure is much more precise yet paradoxically more ambiguous. A sequence of operations and movements occurs as the set of points, lines, and surfaces flickers between hexagon and cube, and as its edges and sides rotate, pivot, fold, and recombine across the page. This drawing prefigures Smith's most recognizable sculptural works from this period—*Cigarette* (1961), *Free Ride* (1962), *Gracehoper* (1962), *Mistake* (1963), and *Moondog* (1964). With each of these sculptures, the condition of liminality is the result of a perceptual oscillation between two and three dimensions with movements that rotate, pivot, and fold. The effect reorients the sculptures' lines, surfaces, and implied volumes as the viewer moves around them. However, the sculpture *Smoke* (1967) is the direct accumulation of the drawing experiments and earlier sculptural works, and returns Smith to the architectural scale of a building. The sculpture also directly returns Smith to D'Arcy Wentworth Thompson's organicism and diagram of hexagonal cells, yet in an abstract manner that is achieved through the impossible and irrational transmutation between hexagons and cubes that simultaneously exist as implied volumes (or negative spaces) that shudder rather than oscillate between dimensions.

At more than two stories tall, forty-seven feet long, and thirty-three feet wide, *Smoke* is akin to a small chapel whose initial concept

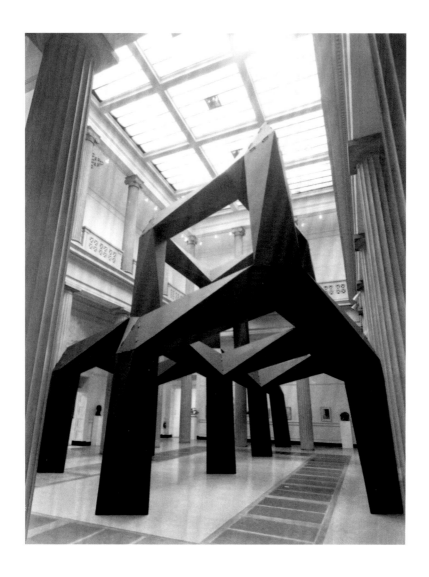

Tony Smith, *Smoke*, 1967, plywood mock-up,
painted black, 24 ft. 2 in. × 47 ft. × 33 ft.
(7.36 × 14.32 × 10 m). Installation view,
Corcoran Gallery of Art, Washington, DC, 1967

Mario Gooden

drawing recalls Smith's Roman Catholic church design from 1950. While conceived to be twice its final size, with fifteen diagonally organized columns, the sculpture is a series of eight columns that define a set of lower-level, hypostyle-like spaces and upper-level vaults and double-height spaces, simultaneously defined by hexagons, cubes, and amorphous polyhedra. The faceted geometries of the sculpture's surfaces appear as elongated tetrahedra that create arched pathways at the lower level while visually and spatially morphing into proximate geometries to define spaces scaled to the proportions of the human body. The geometry of *Smoke* is precise, yet the spatial experience is indeterminate and in continuous transmutation. "The reason that it's called 'Smoke,'" Smith explained, "is that you always think you see a solid. But, a solid always dissolves into other apparent solids. There are no real solids in the voids. It just seems at first, when you're in it, that you are always going to run into a solid. You don't have to be afraid because it's really just like 'Smoke.'"[16]

The achievements of *Smoke* reverberate in Smith's subsequent sculptural works, while those works are also the through line from Smith's earlier architectural investigations. As his later sculptures become more fragmented and abstract, Smith never abandons the root geometries that can be traced backward through the movement and operations of his notepad and graph paper sketches to the architectural drawings. The sculpture Untitled (Atlanta) / Low Bridge (1980) projects a mysterious line in space that begins at the base of the sculpture as the angled edge of a three-dimensional cube, then shifts planes to define a rotation to another planar dimension that rotates the cube to an implied hexagon. This series of operations describes the ambiguities of movements and choreography of space in Smith's black-and-red-ink graph paper drawing that can also be found in his architecture. In the October 13, 1967, issue of *Time* magazine, Smith acknowledges the liminal conditions in his work and the desire for what Fred Koetter describes as a condition in between, and in defiance of direct definition. "My own personal feeling," states Smith, "is that all my sculpture is on the edge of dreams. They come close to the unconscious in spite of their geometry. On one level, my work has clarity. On another, it is chaotic and imagined." The *Time* author further opines

on Smith's sculpture, "Into their creation has gone not only years of architectural experience—which shows in their angular construction and their house-size dimensions—but also years of frustration, of chasing chimeras, tragedy, illness and black despair."[17] Here, the similarly tempered and ingenious architect Francesco Borromini, in his seventeenth-century letter to readers, chimes with Smith:

> I would certainly not have applied myself to this profession with the aim of being merely a copyist, although I know that in inventing new things one cannot receive the fruit of one's labour except later—just as the same Michelangelo received none when in reforming the architecture of the great Basilica of St Peter. . . . And time has now made it clear that all those things of his are considered worthy of imitation and admiration. God be with you.[18]

1 Galileo Galilei, *Il Saggiatore* (1623), abridged, trans. Stillman Drake (December 1960), Stanford University, https://web.stanford.edu/~jsabol/certainty/readings/Galileo-Assayer.pdf.

2 Anthony Blunt, *Borromini* (Cambridge, MA: Harvard University Press, 1979), 50.

3 See the investigative and detailed analysis of Borromini's design sequence and use of 35-palm strategy as the underlying basis for his geometrical relationships in Julia M. Smyth-Pinney, "Borromini's Plans for Sant'Ivo alla Sapienza," *Journal of the Society of Architectural Historians* 59, no. 3 (September 2000): 312–37.

4 Robert Storr, "A Man of Parts," in *Tony Smith: Architect, Painter, Sculptor* (New York: Museum of Modern Art, 1998), 11.

5 Samuel Wagstaff Jr., "Talking with Tony Smith," *Artforum* 5, no. 4 (December 1966): 15.

6 Tony Smith, "The Pattern of Organic Life in America," 1943–45, unpublished manuscript, n.p.

7 D'Arcy Wentworth Thompson, *On Growth and Form*, ed. John Tyler Bonner (1917; Cambridge: Cambridge University Press, 1942), 481.

8 Thompson, *On Growth and Form*, 319–21. Here Thompson cites the detailed description from Stéphane Leduc, *The Mechanism of Life* (New York: Rebman, 1911): "A weak (5 per cent) solution of gelatine is allowed to set on a plate of glass, and little drops of a 5 or 10 per cent solution of ferrocyanide of potassium are then placed at regular intervals upon the gelatine. Immediately each little drop becomes the centre, or pole, of a system of diffusion currents, and the several systems conflict with and repel one another, so that presently each little area becomes the seat of a double current system, from its centre outwards and back again; until at length the concentration of the field becomes equalised and the currents cease. After equilibrium is attained, and when the gelatinous mass is permitted to dry, we have an artificial tissue of more or less regularly hexagonal 'cells,' which simulate in the closest way an organic parenchyma."

9 Wagstaff, "Talking with Tony Smith," 18.

10 Fred Koetter, "Notes on the In-Between," *Harvard Architecture Review* 1 (1980): 64.

11 Koetter, "Notes on the In-Between," 66.

12 Koetter, "Notes on the In-Between," 68–69.

13 Francesco Borromini and Virgilio Spada of the Oratory, *Borromini's Book: The "Full Relation of the Building" of the Roman Oratory* (1725), trans. Kerry Downes (Wetherby, UK: Oblong Creative, 2009), 55.

14 Jay Hambidge, *The Elements of Dynamic Symmetry*, originally published as a series of articles in *The Diagonal*, Yale University, 1919–20; published in book form by Brentano's Inc., New York, in 1926; reprinted by Dover Publications, New York, 1967.

15 Storr, "A Man of Parts," 16. Storr is referring also to the house Smith designed and built for Fred Olsen Jr., below his father's, on the shoreline at the base of the cliff facing Long Island Sound.

16 Tony Smith, transcript of lecture given at the Whitney Museum of American Art, New York, in 1976, Tony Smith Archives, New York. See Storr, "A Man of Parts," 30.

17 [Piri Halasz], "Master of the Monumentalists," *Time*, October 13, 1967, 84.

18 Borromini and Spada, *Borromini's Book*, 55.

Peter L'Official

Outsider Art: Hawai'i, *Haole Crater*, and Tony Smith

On June 23, 1969, Tony Smith wrote an apologetic letter on University of Hawaii Department of Art letterhead to Jane Livingston, then an assistant curator at the Los Angeles County Museum of Art. Smith had been engaged by Livingston to work with the Container Corporation of America—a manufacturer of paperboard products such as corrugated cardboard—on a project in LACMA's original *Art and Technology* program, an initiative that matched artists with companies working in such industries as aerospace, manufacturing, and scientific research.[1] Smith's work with the Container Corporation would later yield a monumentally scaled sculpture: a "cave-like" structure for Expo '70 in Osaka, Japan, that viewers could enter and exit, and whose shape was, according to curator Jennifer King, "inspired by bat caves he had seen in Aruba."[2] But that project was still months away from completion; indeed, it was still in its infancy while Smith was composing his note of contrition. Smith wrote to beg forgiveness of Livingston for what was his delayed response via letter: "As you can imagine," he began, "too many demands have been made on my limited energies." Smith had

UNIVERSITY OF HAWAII

Department of Art

June 23, 1969

Jane Livingston
Assistant Curator
Los Angeles County, Museum of Art

Dear Jane

I apologize for not writing a week ago when I said I would. As you can imagine, too many demands have been made on my limited energies.

The enclosed sketch is the first I shall propose for the piece here. As you see, it is based on "Stinger" which was part of the "Art of the Real" show. Something not shown is that it would have a feature not integrated with the part shown. This would be a free steel stairway [sketch] that would enable people to get into the crater. I think that if I designed the steps into the piece, it would become architecture, or landscape architecture. But.

George Hall · Room 131 · 2560 Campus Road · Honolulu, Hawaii 96822 /Cable Address: UNIHAW

Tony Smith letter to Jane Livingston, July 23, 1969

by treating this element as a utility stairway, the piece remains sculpture, with the stair becoming a sort of "pop" element.

In any case, if I can get them to accept this scheme as a piece of sculpture, except for making arrangements for its erection, I shall be free to work on the Container Corporation project.

My reason for temporarily abandoning the 14-sided form solid as the module for a piece is that it would become too much of an engineering feat. I would prefer to achieve aesthetic and psychological effects. The ingenuity of the corporation's engineering and technical resources would be called upon to helping me achieve such results.

As I once said, in speaking of Amaryllis, I wanted to make a cave. Since I have all the maquette components from which I intended to develop the piece for the campus, and for which I now have no immediate use I'll start to work with them today on your project... I should go to class now.

All the best
Tony

been otherwise engaged in Hawai'i with a wholly different sculptural proposition than the one he owed Livingston and LACMA.

Enclosed with his letter was a sketch of a sculpture that Smith was to propose to the State Foundation on Culture and the Arts in Hawai'i, where Smith had been invited, among other things, to teach a three-credit studio course at the summer session of the University of Hawai'i at Mānoa. Smith's sketched design briefly detailed a square, sunken "pavement" within a larger square stone sculpture, with a metal ladder that allowed the viewer to climb from the ground level down into the sculpture, and thus below the earth's surface. Effectively, what Smith desired to construct was, in his words, a kind of "crater"—a structure that he pointedly did not want to "become architecture, or landscape architecture" but rather to "remain sculpture."[3] The shape of his proposed work was severe and geometrical: a square, flat crater paved with black concrete sunk beneath the ground-level wall—or crater's rim, to extend the visual metaphor. In plan, the sculpture suggested, in the eyes of scholar Joan Pachner, "a beveled picture frame"—but it also might have read to a Native Hawai'ian who beheld it as approximating the natural landform of a volcano.[4] In this way, it might have functioned as a portrait of—or homage to—the land, as well as an almost literal frame for that land. As a site-specific proposal that drew greatly from its surrounding area of Hawai'i—an archipelago of volcanic islands filled with similar craters, both sunken and soaring—*Haole Crater*, as the project would be called, imposed a formalistic artificiality upon its natural environment while striving to achieve harmony with it through its construction materials: the work's projected black concrete would be pigmented by the lava-colored sand that was indigenous to the islands.[5]

Hawai'i was where, as Hawai'ian-born scholar John Charlot argues, Smith first explored his desires to create sculpture that was truly fit to the land; that is, "making the sculpture appropriate *to* its place and also using it to express something *about* that place."[6] The success of such work would then be predicated on a deep knowledge of the intended site—its topography and related geometries for certain, but also its histories, its stewards, and its meanings, past and present. Both Smith's choice of materials and volcanic landform shape

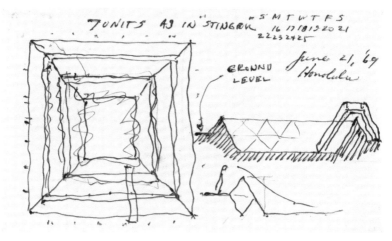

Tony Smith, *Haole Crater*, 1969, ink on paper
envelope, 4¼ × 6½ in. (10.8 × 16.5 cm)

for *Haole Crater* can be read as gestures toward that landscape (as *Bat Cave* at Expo '70 in Osaka was a reference to real Aruban bat caves), and as Smith's way of creating work that engaged with place and site in a more meaningful, intentional way. However, a truly site-specific work of art ought not simply to evoke its surrounding landscapes and histories in homage but also reflect the people who have populated, maintained, been forcibly removed from, or still remain on that land.

Haole Crater is among the most distinctive pieces of unrealized sculpture in Tony Smith's oeuvre, and it is precisely its manner of "unrealization" that accounts for that distinction. *Haole*, in Hawai'ian, can mean any foreigner, but perhaps more accurately it denotes white folks, the English, mainland Americans—or anyone not Hawai'ian by birth or blood. *Haole Crater*, therefore, was Smith's own highly self-conscious—and, perhaps, humorous—acknowledgment of his position as an outsider in Hawai'i and to Hawai'ian culture, as well as the intended sculpture's relationship to the natural landforms that were its referents. Although its materials were to be drawn from resources indigenous to Hawai'i, the square shape of *Haole Crater* marked it as an alien built form, an easily identifiable intruder to

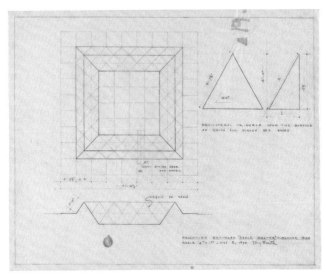

Tony Smith, *Haole Crater* (1969), 1970,
graphite on paper, 19 × 23¾ in. (48.3 × 60.3 cm)

the island. Regarding his choice of title, Smith noted (in a 1971 interview with the writer and curator Lucy Lippard), "It probably means square."[7] One could read Smith's interpretation of *haole* as "square" literally, as the artist understanding that his own work, in small or large part, acted in conflict with Hawai'ian culture and the environment, no matter how much he endeavored to demonstrate the influence of both on his design. But perhaps there is also a hint of Smith's wit in gesturing at the more colloquial, 1970s definition of "square" as old-fashioned or resolutely unhip. Whatever Smith intended by this statement, it was his next line to Lippard about the unrealized *Haole Crater* that remains fascinating to this day: "I would like to make this piece, somewhere or other, but I was talked out of it for the campus project by a Japanese-American student who contended that Hawaii already had too many craters, square or otherwise."[8]

To me, this quote speaks volumes. And to be clear, I want to isolate the speech act of the Japanese American student to Smith

Section drawings for *Haole Crater* (1969), 1970,
graphite on paper, 19 × 23¾ in. (48.3 × 60.3 cm)

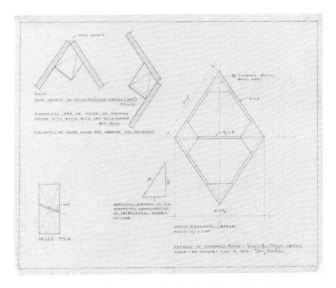

Details of *Stinger* (1967), *Arch* (1968), *Dial* (1968), and *Haole Crater*
(1969), 1970, graphite on paper, 19 × 23¾ in. (48.3 × 60.3 cm)

from that of Smith to Lippard, because I contend that this student's seemingly casual, offhand comment to Smith was nothing of the sort. That is, whether or not it was intended as such, I understand this line to speak not simply volumes but rather *for* the volumes of voices who have historically been unvoiced, silenced, or simply ignored in the violent, interlinked histories of Indigenous peoples and settler colonial populations in North and South America and the Pacific Islands. And here is where you are free to take or leave my "close reading" of this Japanese American student's secondhand quote (I am, after all, a literature professor by trade, and close reading is our tool): I want to suggest it is significant that it was the voice of a nonwhite student, perhaps one well-versed in the code-switching politesse of navigating life in the company of predominantly white figures of authority, that performed this crucial intervention in the work of Tony Smith. I want to read the student's "conten[tion] that Hawaii already had too many craters, square or otherwise" as akin to what Homi K. Bhabha once termed "sly civility" —a form of pointed gentility that is magnificent in

NOTE FROM HAWAII FILES 1969

Tony Smith, handwritten note,
June 28, 1969

its subtlety, and which here guides its intended target (Smith) to the right conclusion via suggestive argument—an argument that manages to say what it *needs* to say, without necessarily saying what it *wants* to say.[9]

That is, I understand this Japanese American student as speaking, as Ralph Ellison would put it, "on the lower frequencies" for the "you" that are nonwhite, particularly Indigenous voices who are rarely, if ever, consulted—never mind listened to—in situations like Smith and this student found themselves in. That Smith both acknowledged and *heard* this complaint—and took it to heart by not following through with the piece—is significant too, and we might look to this seemingly informal engagement as the germ of a methodological model for how future engagements by settler colonial individuals or institutions with Indigenous populations might proceed. Consequently, this essay takes this moment of exchange as a point of departure to discuss Smith's sculpture and what we know as "land art" within the contexts of Indigenous practices, decolonizing methodologies, and relationships with place, space, and site, and it reads Smith's *Haole Crater* (and, to a lesser extent, another unrealized earthwork of Smith's titled *Mountain Piece*) as an understudied hinge point in a more contemporary discourse of Indigenous criticism of land art in the wake of the completion of artist (and Smith contemporary) Michael Heizer's *City* (1972–2022). If "Indigenous" simply means "to be of a place," as scholars Vine Deloria Jr. and Daniel Wildcat suggest, then a consideration of Smith's place-based unrealized artworks through the lens of Indigeneity offers a starting point for discussing what can often be complicated and sensitive issues.[10]

Remarkably, in Smith's papers, there remains reference to the conversation in question. A June 23, 1969, note (which, interestingly, is the same date as Smith's apologetic letter to Jane Livingston) written on a sheet torn from a spiral notepad reads: "Boy objected to piece as being to [*sic*] close to what one is familiar with here."[11] Even as delivered (or merely recorded) here, the notion that Smith's square crater is "to[o]

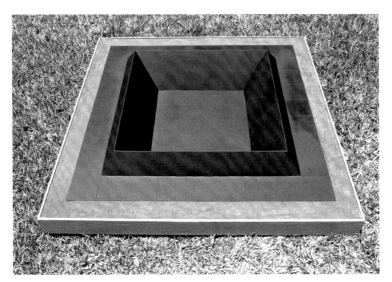

Tony Smith, model for *Haole Crater*, 1969, projected in concrete,
7 ft. × 41 ft. 6⅜ in. × 41 ft. 6⅜ in. (2.13 × 12.66 × 12.66 m)

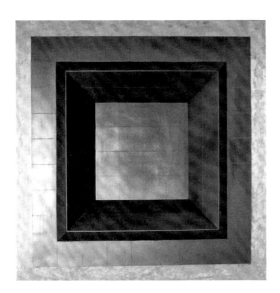

Tony Smith, model for *Haole Crater*, 1969, projected in concrete,
7 ft. × 41 ft. 6⅜ in. × 41 ft. 6⅜ in. (2.13 × 12.66 × 12.66 m)

Peter L'Official

close to what one is familiar with here" evinces a suave logic on the part of the student. The suggestion of needless repetition, of overfamiliarity, perhaps even of the obviousness of the choice of landform shape as sculptural reference—all of these are exquisite, indirect, and yet altogether compelling reasons that would give a thoughtful artist like Smith pause, and they did. Although we cannot know exactly *how* these words were said, the contents of Smith's note, and his recitation of the conversation in the Lippard interview, could be read as the student offering the gentlest of rejections—the public art proposal version of being let down easy.

And—miracle of miracles—it worked! To think of the myriad ways that such an interaction could have taken a left turn, or otherwise become bitter, and to imagine the ways that a different artist might have run roughshod over this objection and satisfied their own original vision, is to approximate the longer—and more common—histories of how these sorts of interactions between local communities and those who wish to place public artworks in their midst have generally

Tony Smith, handwritten note,
June 23, 1969

proceeded. But this exchange also gestures at the equally myriad ways that, historically, persons of color have learned—brilliantly, though often at their own expense—to navigate the whims and wishes of white folks while still managing to register disagreement or otherwise indirectly defy an authority figure, or to defuse an explosive situation. Henry Louis Gates Jr. famously spoke of the African American literary tradition as a "double-voiced" tradition, in that it speaks to Black folks and white folks simultaneously while perhaps saying different things to each audience.[12] That this double voice emerged as a keen method of self-preservation (whether as an aftereffect of the institution of slavery, Jim Crow, or countless other violences arrayed against Black folks) is significant to understanding how this nonwhite student might have approached their own interaction with the artist Smith. Such a simple line reveals a complex web of understandings of social interaction, of readings of personality and temperament, and of experience, here deployed to appeal either to one's vanity, good sense, aesthetic judgment, or sense of ethics—and delivered in a manner that not only manages not to offend *but also* succeeds in achieving a reconsideration of the project as a whole.

That *Haole Crater* remains unrealized is not the only evidence of Smith's hesitancy as a result of this exchange with a student. His archives also speak directly to this: a June 28, 1969, note—just five days after the date of his previous note and letter—reads, "Change title of 'Haole Crater' to Battle Royal."[13] The proximity of this note in time to the original student interaction suggests that Smith immediately recognized the need for a change of tack in the conception of the piece. Gone are both the winking acknowledgment of his and his sculpture's outsider status, and the direct reference to the common landform to which the student objected, claiming that there were already "too many craters" in Hawai'i. The new title, *Battle Royal*, can be taken any number of ways: as a recognition of the disagreement between Smith and student; as a characterization of the relationship between the natural landscape and the transformed sculptural space of Smith's square crater; or perhaps, given that the Hawai'ian scholar Charlot was reminded of the "enormous, round World War II gun emplacements I saw as a child" when he looked at *Haole Crater*'s designs, a

more militaristic reading of the proposed name change is warranted.[14] (In the same set of notes from Smith's "Hawaii files" in his papers, the name "Princess Kaiulani" is written in Smith's cursive on the back of an envelope underneath some mathematical calculations.[15] Ka'iulani was niece to King Kalākaua and Queen Lili'uokalani—who ruled until the US-backed coup d'état in 1893 that overthrew the Hawai'ian kingdom—and last heir apparent to the throne, so it is possible there may also be more literal interpretations of "Battle Royal" as well.) Had *Haole Crater* been built, a visitor who descended the metal ladder that connected the waist-high wall at ground level to the interior floor below would have been able to see only the sky above, so perhaps one final interpretation of "Battle Royal" pits earth against heaven and the self against the infinite—the soul against the sky. *Haole Crater* was, of course, never completed beyond the model stage, so there was no need for Smith to follow through with any name change.

Of Smith's time in Hawai'i, Charlot (a professor of religion at the University of Hawai'i who met Smith through his father, the French-born artist Jean Charlot) writes warmly of the artist's approach to envisioning and creating art inspired by the surrounding area. "Tony Smith is one of a few great artists," Charlot writes in a 1978 article in *Honolulu* magazine, "who have briefly visited the islands, learned quickly and intensely from them, and created works which teach us something about them."[16] He continues later in the same article, "He impressed one immediately with all the intelligence and authority one could have expected. But he was also surprisingly interested in Hawai'i, its land and people. 'This is a magic place,' he once said. 'Inspiring.' He reciprocated by devoting himself to his students and friends and leaving a large number of sculptures as gifts."[17] Charlot retains a wholly positive impression of Smith's engagements with Hawai'i, its people, and its landscape, and particularly with regard to *Haole Crater*, where he senses "a note of culture conflict, of the artist defining himself over and against a culture he is just encountering."[18] There is no reason to doubt Charlot's recollections of Smith; and his readings of what he saw as productive tensions between Smith's positionality as outsider and the sculpture he wished to place into the landscape are encoded within the very title *Haole Crater*. Charlot

also includes Smith's quote recollecting the student's response to the piece, though notably he does not editorialize or comment upon the statement, letting the student's voice speak for itself.

I linger on Charlot's fond impressions of Smith not to suggest that Smith was the sole paragon of how an artist ought to interact with an Indigenous culture and landscape at a time in the late 1960s when many artists—particularly other land art–adjacent or earthwork artists like Smith—claimed some form of Native or Indigenous inspiration for their work. As Pachner observes, Smith drew similar inspirations throughout his career from the monumental Hopewell Mound Group earthworks in Ohio, which Smith once called "the greatest experience that I have felt from a man-made thing in America," and she notes that Smith desired to "create presences that suggested the grandest traditions of ancient history and culture," works that, in Smith's own words, had "more of the archaic or prehistoric look that I prefer."[19] Smith's sculptures, Pachner also notes, have often been compared both by critics and by Smith himself to architectural monuments or archaeological sites and, among other large-scale earthwork artists like Michael Heizer, Smith hoped to create new monuments as artifacts of the present that nonetheless recalled the past. Indeed, many land artists of the 1960s and '70s shared these deep feelings and sentiments toward place, people, and history, and many others made explicit their inspirations from particular Native cultures or practices, acknowledgments that ranged from the earnest to the fetishistic.

However, as scholar and professor of Native American art history Alicia Harris (Assiniboine, Sioux) argues, under the structure of settler colonialism, which reduces the human relationship to land to a relationship to property, "proprietary relationships to land happen *regardless* of individual feelings for place."[20] That is, no matter how kind or understanding or respectful *any* artist might be toward Indigenous peoples and their land, the "proprietary relationship of human to land under a settler state, and the inherent dispossession of Indigenous people that made Land Art possible," preclude even the depth of feeling that Smith may have had (or that Charlot may have sensed) for Hawai'i from carrying the day and evading critique—

especially a critique that centers Indigenous perspectives as opposed to the individual attachments and emotions, no matter how passionate or well-earned, that settlers have experienced.[21] It is not that feelings do not matter, but they are not dispositive, and cannot displace the often violent historical realities of the settler colonial project.

And it is large-scale earthworks like Michael Heizer's recently completed *City* that have invited such critique. The world's largest contemporary artwork, at one-and-a-half miles long and a half mile wide, *City*'s concatenation of pyramids, walls, and mounds sits about three hours northwest of Las Vegas, near the center of the Basin and Range National Monument in Nevada's Garden Valley—on land where the Western Shoshone people still press their claim, as they have done for 150 years. The writer Chris Fernald observes that even despite Indigenous settlement in the region for thousands of years, "Americans tend to see a blank slate" when they think of Nevada, where the federal government still holds 88 percent of all land in the state, and which consequently appears as "a land unburdened by the weight of human history."[22] It is this rather naïve (or perhaps willful) misunderstanding of land and history—and the notions of emptiness and nothingness that seemed so immediately alluring to white land artists like Heizer—that remain troublesome, because that land is hardly empty *of* history. The Pulitzer Prize–winning Diné artist and composer Raven Chacon suggested as much when asked by *Hyperallergic* to respond to descriptions of the area around *City* as empty and featureless: "[Heizer's] father [Robert Heizer]—being an archaeologist, anthropologist, and somewhat historian—would know that people were killed off. People were removed from these lands. . . . So that's what we're looking at: people replacing those that were displaced with their own monuments."[23] What some have seen as more troubling than even the instinctual impulse to see "nothing" when confronted with the wide-open expanses of the American West is what Fernald calls Heizer's own "incuriousness" about the "larger story of the land he digs, cuts, and plows."[24] To Fernald, Heizer's work itself also displayed a certain resistance to engaging with the landscape—*City*'s walls and slopes block lateral views of the landscape, leaving only the sky to see—which suggests to the writer a formal self-containment.

Similarities between Heizer's earthworks like *City* and *Double Negative* (1969–70, in Mormon Mesa, Overton, Nevada) and Smith's site-specific plans—particularly his (also unrealized) *Mountain Piece* (1968)—have been recognized by Pachner and other critics. Certainly aspects of *Haole Crater*'s design recall *City*'s privileged engagement with the sky once behind—and below—its surrounding walls. Smith himself observed an affinity between some of his interests and those of artists like Heizer and Robert Smithson in the late 1960s: "I would say that many of my ideas . . . [are] related to a very large class of works which have to do with work which exists only in place . . . particularly . . . Mike Heizer as someone who is doing—making holes in the ground, sometimes lining them . . . but there isn't any way in which you can transport a hole in the ground."[25] *Mountain Piece* and *Double Negative* share much in this regard: both were predicated on the assistance of industrial-grade earthmovers, dynamite, and other construction equipment in order to create the artwork; and both were designed to be immovable in the sense that they could not be transported or sold, and would likely stand the test of geologic time. *Double Negative* involved the creation of a 1,500-foot-long, 50-foot-deep channel that enveloped

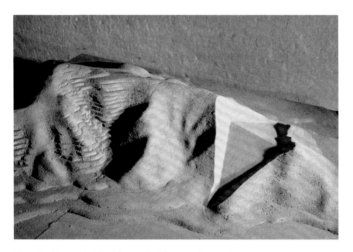

Tony Smith, model for *Mountain Piece*, 1968, earthwork, cut projected at 1,400 ft. across on 45,000-acre property (unrealized)

the viewer in two gargantuan trenches that bracket a natural canyon, and required the displacement of 240,000 tons of soil in order to do so. *Mountain Piece* would have engineered a "cut" into Round Mountain in Valencia, California (bordering the Golden Gate Freeway that connects Los Angeles with San Francisco), excavating the top of the mountain and placing in the resulting monumental divot one of Smith's preferred triangular tetrahedral forms. It would have been a piece designed to be beheld from below and at speed, from a passing car, its shape gradually revealing and uncovering itself until the viewer passes it entirely. But, like *Haole Crater*, we can only imagine how such unrealized works would have truly engaged—or remained isolated from—their surrounding landscapes and embedded histories.

But what should such engagement look like, either in our contemporary era or as we look back on the work of the recent past while centering alternative or heretofore marginalized perspectives? In her book *Decolonizing Methodologies: Research and Indigenous Peoples*, Māori scholar Linda Tuhiwai Smith (Ngāti Awa, Ngāti Porou, Tūhourangi) writes of the phenomenon where "many researchers, academics, and project workers may see the benefits of their particular

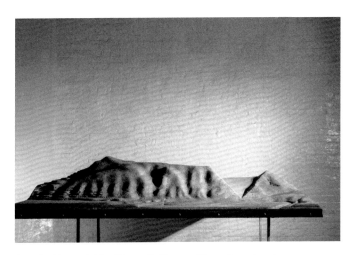

Tony Smith, model for *Mountain Piece*, 1968, earthwork, cut projected at 1,400 ft. across on 45,000-acre property (unrealized)

research projects as serving a greater good 'for mankind,' or serving a specific emancipatory goal for an oppressed community."[26] And in so doing, those researchers often take for granted that they as individuals embody and are natural representatives of an ideal when they work with other communities or histories. Tuhiwai Smith observes that "Indigenous people across the world have other stories to tell which not only question the assumed nature of those ideals and the practices that they generate, but also serve to tell us an alternative story: the history of Western research through the eyes of the colonized." Whether approaching research or approaching an artistic endeavor, the undertaking ought to involve a certain decentering of the self and a reexamination of the preexisting assumptions of that self in relation to the other, Tuhiwai Smith might suggest. Concepts of time and space, important for Tony Smith and many other earthwork artists, are, as Tuhiwai Smith writes,

> particularly significant for some Indigenous languages because the language makes no clear or absolute distinction between the two: for example, the Māori word for time or space is the same. Other Indigenous languages have no related word for either space or time, having instead a series of very precise terms for parts of these ideas, or for relationships between the idea and something else in the environment. There are positions within time and space in which people and events are located, but these cannot necessarily be described as distinct categories of thought. Western ideas about time and space are encoded in language, philosophy, and science.[27]

Additionally, as she observes, land and water—also the palette of earthwork artists—are integral to many Indigenous identities and philosophies: "The relationship between land, waters, trees, rocks, animals, birds, fish, insects, and other things and humans is deeply embedded in language, stories, values, ethics, and social institutions. This is a completely different concept than ascribing human characteristics on to animals and plants. It is not about humanizing the

non-human but recognizing the agency of non-human entities for their own characteristics."[28] What would it look like if we *truly* listened to the land, and in what—or whose—voice would it speak?

For now, we will have to content ourselves with the voice of Smith's Japanese American student, who spoke *for* that land. As Tuhiwai Smith writes, "In Hawai'i, *kanaka Maoli*, or native Hawai'ian researchers, have talked of the many aunties, uncles, and elders whose views must be sought prior to conducting interviews in a community." We might then see Smith's student as having channeled or embodied such familial or community voices when they suggested that the artist might think twice before he proceeded with his sculptural crater. And while the example of *Haole Crater* suggests that the denouement of such engagement involves an open conversation where all parties— human and nonhuman, those present in the room and those present in, or absented from, history—are acknowledged and heard, Tuhiwai Smith might suggest that such a process should actually begin with a reframing of one's own approach. The conversation is merely one part of a methodology that adopts a decentered approach—one mindful of cultures and histories that may differ from or contradict one's own—as an integral feature *of* that methodology.

Of the unrealized *Haole Crater*, there are many things that we as modern-day researchers do not yet (or may never) know. But what we do know is that, to at least one voice that was crucially not his own, Tony Smith listened.

1 Tony Smith to Jane Livingston, Assistant Curator, Los Angeles County Museum of Art, June 23, 1969, Tony Smith Estate Archives.

2 Jennifer King, "From the Art and Technology Archives: Tony Smith," Los Angeles County Museum of Art, *Unframed* (blog), January 6, 2014, https://unframed.lacma.org/2014/01/06/from-the-art-and-technology-archives-tony-smith.

3 Smith to Livingston, June 23, 1969.

4 Joan Pachner, "Tony Smith's Earthworks," in *A Fine Regard: Essays in Honor of Kirk Varnedoe*, ed. Patricia G. Berman and Gertje R. Utley (Farnham, UK: Ashgate Publishing, 2008), 253.

5 Pachner, "Tony Smith's Earthworks," 253.

6 John Charlot, "Tony Smith in Hawai'i," *Journal of Intercultural Studies*, no. 30 (2003): 15.

7 Lucy R. Lippard, interview with Tony Smith, "The New Work: More Points on the Lattice," in *Tony Smith: Recent Sculpture*, exh. cat. (New York: M. Knoedler & Co., 1971), 10.

8 Lippard, "The New Work," 10.

9 Homi K. Bhabha, "Sly Civility," *October* 34 (Autumn 1985): 71–80.

10 Vine Deloria Jr. and Daniel Wildcat, *Power and Place: Indian Education in America* (Golden, CO: Fulcrum Resources, 2001), 31.

11 Tony Smith, handwritten note, June 23, 1969, Tony Smith Estate Archives.

12 Henry Louis Gates Jr., *The Signifying Monkey: A Theory of African-American Literary Criticism* (New York: Oxford University Press, 1988).

13 Tony Smith, handwritten note, June 28, 1969, Tony Smith Estate Archives.

14 John Charlot, "Tony Smith in Hawai'i," 15.

15 Tony Smith, "Hawaii Files," ca. 1969, Tony Smith Estate Archives.

16 John Charlot, "Tony Smith in Hawai'i," *Honolulu* 14, no. 11 (May 1978): 31–34.

17 Charlot, "Tony Smith in Hawai'i."

18 Charlot, "Tony Smith in Hawai'i."

19 Pachner, "Tony Smith's Earthworks," 257–58.

20 Alicia Harris, "Homescapes: Indigenous Land Art and Public Memory," PhD diss., University of Oklahoma, 2020.

21 Harris, "Homescapes."

22 Chris Fernald, "Michael Heizer's Empty Empire," *Hyperallergic*, September 26, 2022, https://hyperallergic.com/764254/michael-heizers-empty-empire/.

23 Jasmine Liu, "What Do Native Artists Think of Michael Heizer's New Land Art Work?," *Hyperallergic*, September 21, 2022, https://hyperallergic.com/763203/what-do-native-artists-think-of-michael-heizers-new-land-art-work/.

24 Fernald, "Michael Heizer's Empty Empire."

25 Pachner, "Tony Smith's Earthworks," 257–58.

26 Linda Tuhiwai Smith, *Decolonizing Methodologies: Research and Indigenous Peoples* (London: Zed Books, 1999), 2.

27 Smith, *Decolonizing Methodologies*, 57.

28 Smith, *Decolonizing Methodologies*, 206.

Christopher Ketcham

A Valid Confrontation: Tony Smith and the Socio-geometries of Urban Space

What is my intention? It is a new measure of man, in terms of free space, in terms of space that is defined but not enclosed, in terms of measurable space that flows so subtly into the infinite that it is impossible to say where the boundaries of art and nature lie.
Tony Smith[1]

In the late 1960s, Tony Smith began to conceive of sculpture not as an object but as a sprawling spatial field embedded in the city. Speaking at a conference in April 1970, alongside leading American architects and urban theorists, Smith envisioned a city block paved with granite but otherwise empty—a vacant expanse of urban space built into but apart from everyday life. "I think the human being walking across it," Smith speculated, "would create a certain kind of intense life which has many dimensions that can't be found in routine patterns of transportation, business, home life and such things."[2] The conference had

been convened by the Walker Art Center and the Minneapolis Planning and Development Department to discuss the problem of Hennepin Avenue. Militating against the strip clubs, dive bars, parking lots, and tangled field of neon signs that animated the area, the conference organizers sought new ideas to shape and project a more wholesome image of the city. For Smith, however, the issue in Minneapolis was not the sordid or media-saturated urban environment. Rather, it was a fundamental problem of urban perception. The shape of the city failed to cohere in embodied experience. The urban plan was incomprehensible, even alienating, to the public. The disjunction between architecture, infrastructure, and mobility stood as an obstacle to knowing the city through the body. It stood as an obstacle to being in the city. Smith's flat, empty expanse of granite would be a liberatory field that could accommodate the mobile body and reorient the subject to the self, others, and urban space. But the subject would also be confronted with the spatial, social, and existential contradictions of the postwar American city.

When Smith spoke in Minneapolis, along with M. Paul Friedberg, Philip Johnson, Walter Netsch, Otto Piene, James Seawright, Barbara Stauffacher Solomon, and Robert Venturi, he had been working almost exclusively as a sculptor for the preceding decade. Yet his proposal was grounded in a theory of urban space in development since the 1940s and '50s, when Smith worked as an architect and builder and was immersed in modernist urban planning and theory. Likewise, his view of the city was shaped and reshaped by his work at the cutting edge of sculpture in the 1960s. Regardless of his field of work, a dynamic concept of urban space remained Smith's preoccupation and theoretical ground.

Yet Smith's biography and historiography would suggest a clean break, and even an opposition, between his career as a designer and builder and his work as a sculptor. Smith abandoned architectural practice in the early 1960s and turned to sculpture as his primary medium. This professional rupture has often been associated with the physical effects of a car accident, which left Smith unable to work on building sites. Smith attributed his rejection of architecture to his unwillingness to compromise design to accommodate the whims of

Christopher Ketcham

clients.[3] Regardless, this break has been reinforced in historiography, which implicitly periodizes Smith's architecture and sculpture as, respectively, early and mature work, in part because of the assumed significance of his contributions in these competing fields of critical discourse. His sculpture stands at the contentious center of postwar art history, and it remains a rich foundation on which artists continue to develop. On the other hand, his building projects from the 1940s and '50s were and remain relatively unknown. But Smith's approach to sculpture was fundamentally informed by his study of urban planning and theory. Moreover, his work as a sculptor brought him into direct and sustained contact with the power brokers shaping the American city, including Planning Commission director Edmund Bacon in Philadelphia, and John Lindsay and his mayoral administration in New York City. These encounters enlarged Smith's view of sculpture in the modern city and sharpened his theory of urban space.

Philadelphia

In the mid-1950s, as Smith traveled through Europe, visiting the latest buildings designed by Le Corbusier and Mies van der Rohe and reflecting on the growth of modernist architecture in New York City, he began to worry over the spread of towers isolated in plazas. Smith admired the form of Le Corbusier's Unité d'habitation in Marseille, Wallace Harrison's United Nations Secretariat Building, and Gordon Bunshaft and Natalie de Blois's Lever House in New York City. These buildings, Smith believed, reinforced the urban grid and reflected the essential geometry of urban space in a vertical register. However, he lamented the open spaces that surrounded these new towers and isolated architecture from the urban field. For Smith, the modernist tower-in-the-park established an opposition between form and space, with the latter rendered empty, meaningless, and lifeless. "I am thinking closer to painting and sculpture in the sense of a juster balance between the solids and voids," Smith wrote in 1954, "and one in which the voids become active with as much form and intention as the buildings. . . . The city would not be in the midst of parks, or at

Tony Smith, *The Lesson of Paris*, 1953, page from Sketchbook #74, ink on gridded paper, 8⅛ × 10⅝ in. (20.6 × 27 cm)

least it wouldn't be a lot of buildings spread out among the trees. I would consider everything outside the city The Wild."[4] The new form of modernist urbanism, issuing from architectural monoliths surrounded by open plazas and expansive lawns, ran counter to Smith's idea of the city.

The plaza was a new spatial form in the postwar American city and a central part of an urban renewal doctrine conceived to alleviate the social and architectural densities of the nineteenth-century city. When Smith was writing and studying urban theory in 1954, the plaza had not yet come under the withering critique that would animate the discourse of the city in the 1960s. But he had already recognized the suburban or antiurban nature of these new open spaces. Over the next decade, as plazas spread throughout New York City, fronting new corporate headquarters and residential developments in Midtown and Lower Manhattan and the Lower East Side, the suburbanization of urban space would be decried by Jane Jacobs, Ada Louise Huxtable, Vincent Scully, and many others. Like Smith, these leading urban and architectural critics, theorists, and historians saw the proliferating plazas as a suburban intrusion that constituted a form of violence against

the social life of the city.[5] The plaza was seen to constitute a threat to the humanity of urban space.

Smith's first major exhibitions were mounted amid this critical environment. In multiple shows in 1966 and 1967, his sculptures were positioned in plazas to orient the public and catalyze social activity within the new open spaces of the postwar American city. The first solo exhibition of his sculpture was held jointly by the Wadsworth Atheneum in Hartford and the Institute of Contemporary Art (ICA) in Philadelphia. Both venues, curated respectively by Samuel Wagstaff Jr. and Samuel Adams Green, featured multiple sculptures in public spaces around the museums. Most dramatically, *Cigarette* (1961) was installed in Tower Square, the plaza fronting Travelers Tower, Hartford's largest office building. *Cigarette* is composed of four prisms, based on the modular extension of a tetrahedral unit. It stands fifteen feet tall and spans twenty-six feet. The prisms form an asymmetric arch under

Skidmore, Owings & Merrill, Lever House, 1952, New York City

and through which people can walk. In Hartford, as one moved around or through *Cigarette*, its angular black lines would seem to fracture the surrounding mass of buildings, breaking up the uniformity and insistent verticality of their façades. It also impinged upon the routine movement of workers traversing the space. Smith's unpredictable, inassimilable forms altered the embodied experience of the plaza, interrupting the social and architectural organization of space.

Smith saw works like *Cigarette* and others installed in Hartford and Philadelphia as a negation of the formless, open space of the plaza, objects around which the subject could be reoriented to the geometries of urban space. "These figures, whether based upon rectangular prisms, tetrahedra, or other solids, may be thought of as part of a continuous space grid," he asserted. "In the latter, voids are made up of the same components as the masses. In this light, they may be seen as interruptions in an otherwise unbroken flow of space."[6] The stark geometry of the towering black sculpture was grounded in Smith's view of the geometry of the city. But the form of *Cigarette*, and many of Smith's sculptures from the early 1960s, was equally derived from his obsessive assembly of simple modules that formed fragments of complex grids.

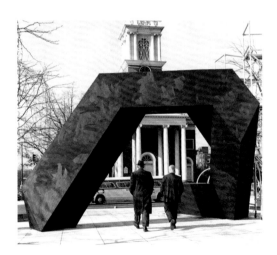

Tony Smith, *Cigarette*, 1961, plywood mock-up, painted black, 15 × 26 × 18 ft. (457.2 × 792.5 × 548.6 cm). Tower Plaza, Hartford, CT, 1966

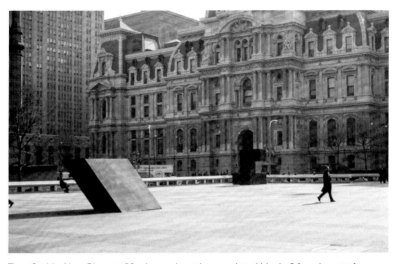

Tony Smith, *New Piece*, 1966, plywood mock-up, painted black, 6 ft. 11 in. × 12 ft. × 14 ft. 2 in. (210.8 × 365.8 × 431.8 cm). Installation view, *Art for the City*, Institute of Contemporary Art, University of Pennsylvania, Philadelphia, 1967

The negative space of the sculpture—the space that one could occupy and move through—was organized by the same modular geometry that the sculpture was built out of. But the logic of the module and the regular order of the grid were overwhelmed by the irrational extension of forms that seem to rise or fall, open or close, sprawl or merge, depending on one's viewpoint. This core contradiction between rational and irrational form generated unpredictable experiences of urban space, architecture, and sculpture as one moved through the plaza. What had been a void between buildings—a space that one could traverse unconsciously—was interrupted by *Cigarette* and temporarily transformed into a dynamic space of aesthetic experience.

The exhibition in Philadelphia, held at the same time as and in conjunction with the show in Hartford, featured four sculptures installed in the public spaces around the ICA. The installation in Philadelphia, which included plywood mock-ups of *Marriage* (1961), *Night* (1962), and *New Piece* (1966) and a half-scale model of *Cigarette*, lacked the drama of the full-scale version of *Cigarette* in Tower Square. But it brought Smith's work in direct contact with Edmund

A Valid Confrontation

Bacon, Philadelphia's master planner and a giant in the development of an American modernist urbanism. After the solo exhibition closed in January 1967, Samuel Adams Green kept the same four sculptures to anchor *Art for the City*, a group exhibition that opened at the ICA just a few weeks later. Green had intended to distribute Smith's four works around the campus of the University of Pennsylvania, along with the work of several other artists, most associated with New York City's Park Place Gallery. When university administrators balked at the proposal, Green worked closely with Bacon to place the sculptures in the city's public spaces.[7] The two settled on the most prominent plazas and open spaces in Bacon's newly designed urban core, including Society Hill Towers and Penn Center. Smith's four sculptures were installed around the recently opened Municipal Services Building, designed by Vincent Kling, who collaborated with Bacon on the architectural design of the new Philadelphia. All of the buildings around

Vincent Kling & Associates, Municipal Services Building, 1962–65, Philadelphia. Courtesy of Fisher Arts Library Image Collection, n2017040104

Christopher Ketcham

which Green and Bacon mounted *Art for the City* were archetypal modernist towers surrounded by open plazas.

Bacon had been a critic of the tower-in-the-park model of urbanism. But his master plan for the urban renewal of Philadelphia relied heavily on modernist towers set in open plazas and expansive lawns. Society Hill Towers, for example, was a prominent residential development designed by I. M. Pei and an important part of Bacon's urban plan. An archetypal slum clearance scheme, Pei's three identical thirty-one-story towers set on a five-acre site replaced a dense, mixed-use neighborhood that had been consolidated as a property and razed by the city.[8] Just one year before Society Hill Towers opened, Bacon had lamented "modern skyscrapers set in flowery suburban lawns . . . which can only result in a sort of imported hybrid semi-suburbia in an inhospitable city setting."[9] Yet, when Pei's buildings were completed, Bacon championed Society Hill Towers as a model residential development and a means of appealing to affluent families who were otherwise attracted to the suburbs.[10] Likewise, Kling's Municipal Services Building, where Smith's four sculptures were installed, was a paradigmatic modernist office tower—a seventeen-story vertical grid of glass and granite surrounded by an empty frame of open plazas.

The "continuous space grid" that Smith saw as the generative ground of his sculptures and the essence of the city was palpable in the architectural design of the Municipal Services Building and the urban plan around it.[11] It could be seen and felt in the gridded curtain walls of Kling's tower, the tiled plaza, and the regular order of surrounding streets. Two of Smith's four sculptures reinforced the geometry and spatial order of the site. *Night* and *Marriage* were both composed of modular rectangular prisms, with vertical and horizontal elements connecting at ninety-degree angles. *Cigarette* and *New Piece* were also grounded in grid forms. But their eccentric geometries, based on Smith's play with tetrahedral and dodecahedral modules, established a more complex spatial order that broke with the surrounding architectural field. As it did in Hartford, the sprawling, arching form of *Cigarette* stood as a lineal break with the regular order of space established by the building, plaza, and urban plan. The massive rhomboidal form of *New Piece*, standing twelve feet

tall and spanning eighteen feet, obstructed and negated the open expanse of space.

All four of the sculptures installed around the Municipal Services Building were grounded in basic geometric forms. But the geometry of each form was irresolvable in immediate perception and irreconcilable with the surrounding architecture. Smith saw the formal complexity, derived from his play with basic geometric modules, as a means of breaking with the underlying logic of existing space. "Almost everything in the man-made environment, and even in much of nature, is regulated by axes of length, breadth and height," Smith suggested in 1968. "The elements from which many of these pieces are made have more axes, and the forms developed from them move in unexpected ways."[12] But the forms do not move. They are set in motion as one walks around, under, and between them and perceives the line, mass, and form of the sculptures against the orderly field of architecture and city in the background. The scale of *Marriage*, *Night*, *New Piece*, and *Cigarette* was keyed to the bodies moving through urban space, rather than to the architectural environment. All except for *New Piece* incorporated spaces that one could inhabit or move through—openings, arches, or projective elements that framed open space.

Smith saw the geometry of urban space as shaped and imposed by the architectural environment. But he recognized that social activity—bodies moving through the city—counteracted the rational order of the architectural surround. He envisioned his sculpture as a catalyst for social activity that would disorder the grid. The geometry of his work compelled a dynamic, embodied encounter, according to Smith. "You can move around a cube, get in the shadow, see the planes," he asserted, "it's a social form."[13] Such sculpture could stand as an objective node around which a participatory urbanism could cohere. At the same time, a form of sculpture that was grounded in the grid could make the geometry of urban space perceivable to those same bodies. In walking around *New Piece* or *Cigarette*, or occupying the open spaces of *Marriage* and *Night*, one could experience the core contradiction between rational structure and irrational form, or between conceived and perceived space. One could also

experience the geometric order of urban space, recast as the regulative ground interrupted by Smith's sculpture.

Smith's earliest critical advocates, including Robert Morris, Lucy Lippard, and Scott Burton, recognized the mobile and participatory encounter that cohered around sculptures like *Cigarette* and *New Piece* as a new aesthetic experience.[14] This new aesthetic ideal also echoed the core terms of Bacon's project to invest meaning in urban space and reorient the subject to the city. Bacon, who worked closely with Green on the placement of sculpture in *Art for the City*, also wrote the introduction to the exhibition catalogue. In his brief essay, Bacon suggested that artists such as Smith had a key role to play in the remaking of the American city. The modern artist, he argued, must become "a valid participant in the life of the city" and reject the avant-garde's isolation from society.[15] "There is no doubt," Bacon wrote, "that this action will result in a collision because the artist and the people have allowed themselves to stray far apart. The time has come for such a confrontation, and it will be a valid confrontation because it occurs in public places."[16]

Beyond a valid confrontation, Bacon did not articulate the significance of sculpture in the city. But in *Design of Cities*, Bacon's major treatise on urban planning, published later in 1967, he argued for a participatory and embodied urban experience that echoed the phenomenological aesthetic theory being written around Smith's sculpture. "Architecture," Bacon wrote, "is the articulation of space so as to produce in the participator a definite space experience in relation to previous and anticipated space experiences."[17] A participant, according to Bacon, would be an active user of the city who comes to know urban space through the body. Bacon believed that the city must be coherently shaped to communicate urban space to the public in a way that was intelligible through mobile, embodied experience. "It is one thing to delimit space by structural devices such as walls. It is quite another to infuse the space with a spirit which relates to the activities that take place in it and which stirs the senses and emotions of the people who use it."[18] For Bacon, the meaning of the city was grounded in the immediate sensation and embodied perception of urban space. In turn, a meaningful urban space would,

he argued, provoke a heightened awareness of the environment and a more active, critical engagement with the city. Modernist architecture would not accomplish these goals alone. Sculpture, as Bacon suggested in his introduction to *Art for the City*, could play an important role in catalyzing this ideal of participatory use and primal knowledge of urban space. It was a means through which the subject could come to know the city and an object around which a new urban spirit could cohere.

For Bacon, the production of spatial meaning and the reorienting of the urban subject were urgent projects in the wake of the wholesale urban renewal of Philadelphia. And they were urgent projects, specifically, in open plazas, such as those surrounding the Society Hill Towers and Municipal Services Building, which were widely condemned as formless, meaningless, antiurban, and inhuman. Smith's sculptures promised to interrupt these vacant spaces and catalyze embodied and participatory urban experience. Smith and Bacon were part of a shared discourse of the city, critically assessing the new spaces of urban modernism—its potentials and deficits, the new modes of experience and perception organized by the city, and the ways of knowing the city and its architectures through embodied experience. For both, sculpture could be an instrument in the reshaping of urban space and reorienting of the public within it.

New York City

But there was a hostility in Smith's view of sculpture that ran counter to the utopic sensibility that animated Bacon's image of the city. While the geometry of works like *Cigarette* and *New Piece* was informed by the underlying urban grid, Smith made clear that their presence in the city was aggressive and confrontational. "I think of them as seeds or germs that could spread growth or disease. . . . They are black and probably malignant."[19] Just three years before Smith made these comments, Norman Mailer had described modernist architecture as a cancerous threat to the city.[20] Smith embraced the logic of Mailer's argument but turned it on its head. Rather than saving the Beaux-Arts

city of Mailer's memory from modernism, Smith viewed sculpture as a malignant node around which a critical and embodied perception of modernist urban space could cohere and around which the geometry of urban space could be disordered. According to Smith, the latent malignancy of sculpture relative to the city was a product of the sculpture's suburban basis.

In 1966 and '67, when Smith's first significant exhibitions were mounted, his sculptures were known almost exclusively through a suburban frame. *Marriage*, *Night*, *New Piece*, *Cigarette*, and all of Smith's sculpture made before 1966 were conceived with a view toward his backyards in New Jersey. He saw this context not just as a site of experimentation and construction but as the natural and most appropriate home for his work. In a 1968 interview, he positioned the suburbs as generative. "The work was done at a time when I never thought of it in connection with the art world, whatever. I thought of it in relation to my backyard. . . . I saw a void out there among the leaves and got a certain amount of kick out of filling it."[21] In a statement published a few years later, he would echo this suburban grounding of sculpture and extend it to include the pastoral. "The geometrical character of these earlier sculptures seemed most compatible in landscaped areas, on lawns, against trees, in situations where their large, simple and clear planes were seen in contrast to the open spaces, or the smaller grain and irregular patterns, of nature."[22]

The suburban ideal was not important solely to Smith. It was also the context through which most people were first introduced to his work. In an interview with Samuel Wagstaff Jr., published in the December 1966 *Artforum* to publicize the exhibition in Hartford and Philadelphia, ten of the sixteen photographs of Smith's sculpture were set in his yard, framed by an unkempt lawn and a leafy surround of trees and shrubs.[23] This interview became a ubiquitous point of reference for his peers and critics. As Robert Morris, Michael Fried, and Robert Smithson debated the aesthetics of Smith's drive on the unfinished New Jersey Turnpike, they were looking at photographs of *Spitball* (1961), *Playground* (1962), *Willy* (1962), and *Amaryllis* (1965) filling voids among the leaves in Smith's backyard.

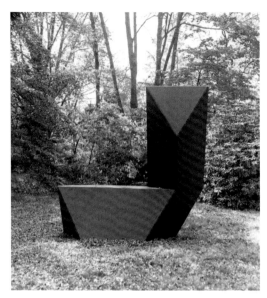

Tony Smith, *Amaryllis*, 1965, plywood mock-up, painted black, 11 ft. 6 in. × 7 ft. 6 in. × 11 ft. 6 in. (350.5 × 228.6 × 350.5 cm). Orange, NJ, 1966

The article in *Artforum* positioned the suburbs not as a site of work or domestic life but as a spatial and conceptual field in which Smith's sculpture and a new, expansive aesthetics were grounded.

The malignant potential of sculpture in the city rested on the opposition between urban and suburban frames, according to Smith. "The pieces seem inert or dormant in nature," he suggested in 1966, "and that is why I like them there, but they may appear aggressive, or in hostile territory, when seen among other artifacts. . . . If not strong enough, they will simply disappear; otherwise, they will destroy what is around them, or force it to conform to their needs."[24] In Philadelphia, Ed Bacon sought an aggressive negation of empty space that he had characterized as an "imported hybrid semi-suburbia."[25] The dark, looming forms promised to make the city more urban. However, in the public spaces of New York City, Smith's works were promoted by municipal authorities for the opposite reason—because of their suburban frame of meaning.

In January of 1967, coinciding with *Art for the City* in Philadelphia, Smith installed an exhibition of sculptures in Bryant Park. It was his first solo exhibition in New York City and the first exhibition of public art ever mounted by the municipal government—a momentous occasion for both artist and city. The exhibition was organized by Thomas Hoving, the city's first parks commissioner in the mayoral administration of John Lindsay. Mounted just one year after Lindsay was inaugurated, the exhibition of Smith's sculpture was an exercise in spatial authority. With Hoving's guidance, Lindsay had campaigned on a promise to reclaim the city's parks from the publics that did not conform to Lindsay's image of the city. The exhibition of Smith's sculpture was one of the first concrete steps that Lindsay and Hoving took to stake their new claim to the city's parks.

Lindsay had closely associated the state of the parks with the state of the city.[26] While campaigning for mayor in 1965, he condemned the social and physical condition of the parks and, implicitly, Robert Moses's management of public space. In the campaign's white paper

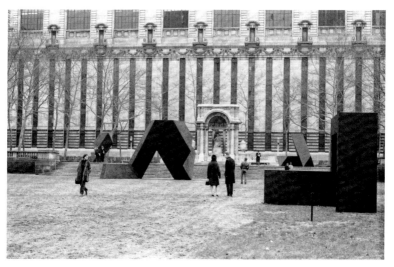

The Snake Is Out and *Marriage* (foreground), *Amaryllis* and *Spitball* (background), plywood mock-ups, painted black. Installation view, *Tony Smith: Bryant Park*, New York, 1967

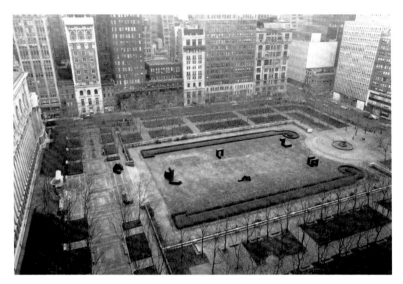

Installation view, *Tony Smith: Bryant Park*, New York, 1967

"Parks and Recreation," authored by Hoving, Lindsay argued that the public perceived the city's parks as dangerous and deteriorating. Their decrepit state, the campaign suggested, was the antithesis of the nineteenth-century pastoral ideal on which the parks were founded to promote open space, health, and recreation in the city.[27] More importantly, the public image of deviance that cohered in city parks was an obstacle to Lindsay's ideal of corporate leisure and family-friendly recreation. Bacon's management of urban planning in Philadelphia, and his functionalist view of art, served as an immediate model for the Lindsay administration to reclaim the city's parks and remake the publics that used them.[28] Following Bacon, the Lindsay administration believed that advanced sculpture could attract new users to parks and reorient the public to the city.

Two weeks after Smith's solo exhibition opened in Hartford and Philadelphia, Wagstaff sent a letter to Thomas Hoving, suggesting the show for a New York City park.[29] Hoving, who had been appointed parks commissioner by John Lindsay in January of 1966, promptly signed on to the idea.[30] Wagstaff assumed the exhibition would take

Christopher Ketcham

place in Central Park, but Hoving decided on Bryant Park. Barbaralee Diamonstein, Hoving's Special Assistant for Cultural Affairs, wrote to Smith to clarify the location, promoting the open space and the architectural frame of Bryant Park, which is more immediately felt than in Central Park. "The open park area against the strong architectural background," Diamonstein suggested, "will, we think, make a particularly effective and relevant setting."[31] Open space and architecture were not the only merits, however. Located in the heart of midtown Manhattan, Bryant Park was a key site in Lindsay's plan to reform the city's open spaces, reorient the body politic, and project a new image of the city.

Lindsay and Hoving imagined the city's parks, particularly those in commercial and business districts, to be spaces apart from and devoid of urban activity. These parks should be "a pool of space removed from the flow of traffic . . . an outdoor living room, human in scale, enclosed and protected, and sheltered from noise."[32] Hoving emphasized the need to restore pastoral park spaces, especially in midtown Manhattan, to provide places of rest and stimulation for office workers. The midtown park, Hoving suggested, "should be imaginative—something more than pavement to walk on. It should be a delight to the eye."[33] But these goals for Bryant Park were in stark contrast to the realities of its use in the mid-1960s. It was not a pastoral oasis for the corporate managers who populated the surrounding buildings, nor a place to rest and refresh the senses. According to the Lindsay administration, Bryant Park was a site of danger, deviance, vagrancy, and vice. Police reports had suggested that Bryant Park, a block from Times Square, was merely a hangout for "winos and homosexuals."[34] And just a few months before agreeing to host Smith's exhibition, Hoving pronounced Bryant Park, "a disaster area because of the people who frequent it . . . the slimiest elements of society."[35] Yet he hoped to transform the park into "an entertainment magnet, attracting better people." In Bryant Park, the Lindsay administration sought to project an image of corporate hospitality through the imaginative use of open space. Moreover, Hoving and Lindsay sought to organize a body politic in the midtown park that conformed to their corporate ideal. The Tony Smith exhibition was the first step the administration took to produce this new, corporate public.

A Valid Confrontation

To accommodate this ideal public and to discourage non-conforming uses of Bryant Park, Hoving sought a return to the nineteenth-century pastoral spaces in the city. He had suggested that this pastoral ideal was conceived to "eradicate even the faintest trace of urban activity."[36] Hoving was aware of the suburban frame and Smith's characterization of his work as hostile to urban space. Smith's statement regarding the hostility of his sculpture when removed from nature was promoted in a Department of Parks press release.[37] Hoving's implicit goal in introducing Smith's work to Bryant Park was to transfer their bucolic spatial frame to the heart of the city, supplanting urban vice with suburban social values. The malignant potential that Smith attributed to his sculpture had a functional value, for the Lindsay administration, of disrupting the existing social and spatial order of the park.[38]

Five of Smith's sculptures were placed on Bryant Park's great lawn: *Night*, *We Lost* (1962), *Marriage*, *The Snake Is Out* (1962), and *Willy*. *Amaryllis* and *Spitball* sat on the park's upper terrace, between the great lawn and the rear façade of the New York Public Library. For the most part, the sculptures were arranged in harmony with the rigid formal landscaping, arranged in pairs along the park's central east-west axis. The ambulatory experience associated with Smith's work also constituted a return to the leisured walking that was part of Bryant Park's original design. As in Hartford, *Cigarette* functioned as an arch and obstruction. Placed at the formal entrance to the park on 6th Avenue at 41st Street, it reorganized the flow of movement by forcing pedestrians to go through or around it. Likewise, *The Snake Is Out*, another massive arching form composed of tetrahedral prisms, stood between the park entrance and the library. This position not only obstructed the stairs leading from the great lawn to the upper terrace but also disrupted the sight lines organized by many of Bryant Park's landscaped features. In other words, *Cigarette* and *The Snake Is Out* disrupted the sensorial organization of the park and the spatial protocols of movement that followed from that organization.

It is difficult to see how Smith's sculptures were more at home in the suburbs than the city. It is true that their asymmetric geometries cutting through space in unpredictable angles contrasted with

the insistent verticality of the urban architectural environment. Their rough, black-painted surfaces diverged from the orderly grids of gray stone, red brick, glass, and steel surrounding them. There was nothing quite like them in the city, nor in the nascent field of public art. However, it is even more difficult to see how these formal qualities would communicate a suburban or pastoral ideal. Yet this is exactly how they were received.

In an extraordinary account of the exhibition, *New York Times* art reporter Grace Glueck simply recorded quotes from parkgoers, almost all of whom cast the sculpture as an antidote to the urban environment. "It gives a little class, a little culture, to the park," reported a visitor from Queens. "They make the park look more like a park," a sanitation department employee added.[39] A feature article in *Time* suggested that Smith wanted to create "architectonic mastodons, varied enough to refresh the eye after a stark grid of city walls and streets."[40] Harold Rosenberg, likewise, set his experience of the sculptures apart from the experience of the city. "Smith's constructions, for all their feeling of weight, communicate a sense of intangibility alien to this park enclosed by high buildings and heavy traffic," Rosenberg reported. "The geometrical compositions, all different, are beautifully angled to infuse into their immediate surroundings a sense of gentle motion, as of a ship at anchor."[41]

Even those critics who asserted the architectural basis of Smith's work recognized its functional difference from the buildings framing Bryant Park. Hilton Kramer described the influence of the International Style on Smith's sculpture but distanced it from what he argued was a bankrupt architectural paradigm. Kramer credited Smith with preserving "a purity of vision now fallen on evil times."[42] Finally, in one the most significant reviews of the exhibition, Michael Benedikt wrote, "Coming from the bustle of the surrounding streets and onto the Smith site was, indeed, an event in itself. The works have an enormous calming presence." Benedikt seemed completely convinced by the pastoral transformation of Bryant Park provoked by Smith's sculpture. "He seems to want to engage, not rectilinear box structures . . . but the irregular outdoors, with its rolling ground, indeterminate lateral spaces, skies."[43] Even while surrounded by massive walls of stone,

concrete, brick, and glass, Smith's work prompted Benedikt to experience the city as a verdant pasture.

For Lindsay and Hoving, the bucolic experience of rolling hills and gentle waves described by these critics would have satisfied their goal to establish a pastoral retreat in midtown Manhattan. Smith's sculptures seemed to recast Bryant Park as a place to relax, refresh the senses, and immerse oneself in nature. They established, one could say, a suburban ideal in the heart of the city. The lofty rhetoric of open space and pastoral experience echoed the Lindsay administration's goals for New York City parks, which in turn were tied directly to the mayor's support for the corporatization of urban space. The pastoral experience that seemed to cohere around Smith's work countered the popular view of city parks as sites of danger and vice, constituted a territorial claim against existing users, and projected an alternative image of the city as a space of corporate labor and leisure.

For Smith, however, the exhibition was ineffective because the architectural surround overwhelmed the sculptures. The exhibition failed, one could say, because the sculptures were suburban. "My pieces so far have not been made for city spaces," Smith asserted, "they have just been put into them."[44] As a result, the sculptures appealed only to the eye and not the body. "What was plastic in suburbia," Smith wrote, "became graphic in the city."[45] When moved from his backyard in New Jersey to Bryant Park, *The Snake Is Out*, *Amaryllis*, and *Willy* did not function as sculptures but as lines against the urban surround. They had no substantial relation to the city and were reduced to mere marks.

Minneapolis

After Bryant Park, Smith sought to develop a truly urban sculptural form. To avoid the graphic reduction that rendered sculpture insignificant in the city, he sought to incorporate the mobile body as a plastic element within the sculptural space. Rather than conceiving of sculpture as an object to be placed in the city, Smith developed an idea of sculpture as a spatial field—a para-architectural space to

accommodate moving, sensing, and perceiving subjects. Smith argued that a truly urban sculpture could ameliorate the sensorial burden of the city and stimulate the social without acting as a malignant antithesis of the urban. On the contrary, in the wake of his exhibitions in Bryant Park, Hartford, and Philadelphia, Smith saw urban sculpture as an open space of aesthetic experience grounded in the existing geometry of the city plan. A spatial field of sculpture could better synthesize the opposed scales of *body* and *building* than a bounded object that could only be conceived in relation to one of these terms. And, perhaps informed by the exclusionary spatial politics in Bryant Park, Smith further insisted that the new sculpture would be universally accessible. But, more than equitable access, Smith began to think of public sculpture as an obstacle to the capitalization of urban space—a spatial field grounded in the practices of urban renewal and the geometry of the grid but resistant to development and instrumentalization. In place of new buildings, he imagined an existential field—a sculpture that could restore humanity to the city.

When Smith arrived in Minneapolis in 1970 to present his idea of urban space and sculpture at the Hennepin Avenue conference, he had already worked away from the monolithic presences and eccentric geometries that had been dispersed in Bryant Park and around the Municipal Services Building in Philadelphia. In the ensuing three years, working primarily in art contexts, Smith built numerous sculptures, such as *Smoke*, *Source*, and *Stinger* (all 1967), which could accommodate the mobile body of the viewer. As his sculptures opened out with projective forms, framing walls, and towering lattices, the works established interior spaces that could house mobile, perceiving, and participatory bodies. As it occupied larger and larger footprints, a concrete territoriality was built into sculpture such that the body and the surrounding environment were claimed for the work of art. Social and aesthetic experience were conflated and positioned against an urban context in which both seemed to be constrained by thoughtless planning and repetitive modernist architecture. Plans were in the works for vast sculptural fields, such as *Lunar Ammo Dump* (1968), *Hubris* (1969), and *81 More* (1971), which Smith conceived to be built on the scale of the city. Urban sculpture would no longer be a thing to look at. Instead,

Tony Smith, *Stinger*, 1968, plywood mock-up, painted black, 6 × 32 ×
32 ft. (182.9 × 975.4 × 975.4 cm). Installation view, *The Art of the Real:
USA 1948–1968*, Museum of Modern Art, New York, 1968

it would be a space to be in, informed by the gridded geometry of
urban space but opposed to architectural projections of power.

Smith's conference presentation was organized around a specu-
lative proposal for a sprawling spatial field that he had first articulated
in 1968. "I was once asked about urban renewal," he recalled from
the podium. "So, in reply to that, I said, that I should like them to
tear down a block here and there but to do absolutely nothing with it
except pave it—pave it with something very hard—granite or some-
thing like that—no grass—no trees, no street furniture—no lamp
posts, anything, just to have some sense of a piazza where people
could not only confront one another with any degree of identity that
they cared to have, but where in a certain sense they might have a
sense of themselves as unrelated to anything else." In Minneapolis,
Smith positioned this spatial field of sculpture as a response to a crisis
in American urban planning and infrastructural development. "So
many buildings have been torn down, that when we are in the down-
town area, instead of feeling the sense of the streets in the classical

way . . . we have a sense of being somewhat lost—that is, one wanders around looking for the most intense urban life that Minneapolis offers."[46] Aesthetic experience, he suggested, could constitute an existential field of being and becoming amid an inhuman urban environment.

In the 1968 interview that aired on CBS's *Eye on Art*, when Smith first articulated the idea that would become *Project for a Parking Lot*, his speculative space of sculpture was more bluntly tied to urban renewal. "I would almost rather look at nothing than something," Smith had asserted. "If I were a town planner, I would knock down those buildings just the same as all the other town planners, except for the fact that I wouldn't build anything else up on it. I would pave one of them—I mean, not even greenery or anything like that, just some statement of some kind of fundamental humanity. It might be just something about taking a 200 × 800 city block and paving it with

Tony Smith, *Hubris*, 1969, projected in concrete, 5 × 82 × 41 ft. (1.52 × 25 × 12.5 m). Visualization

granite that might say something human too."[47] As in Philadelphia and New York City, Smith's idea of sculpture was embedded in the discourse of open space in the city. But in *Project for a Parking Lot*, the contextual frame of nature and the theoretical frame of the pastoral were abandoned in favor of an entirely urban conception of sculpture and open space.

Whereas Smith's sculptures exhibited in Bryant Park were originally conceived to fill a void in his backyard, he now conceived of sculpture as the void itself. In this intense, immersive experience of space, the subject would be oriented to the city, self, and others. Rather than imagine the vacant space of urban renewal as a blank slate for speculative real estate, Smith appropriated and refined the city, negating the architectural claim on space. In place of building, he imagined the potential of sculptural space and aesthetic experience to ameliorate the problems of orientation and alienation caused

Tony Smith, *Project for a Parking Lot*, conceptual plan, 1970. Published in *Design Quarterly: Conceptual Architecture*, no. 78/79 (1970): 65

Christopher Ketcham

by urban renewal. The humanity of the city would no longer be figuratively imposed on a park, as it was in Bryant Park. Rather, in *Project for a Parking Lot*, Smith worked to clarify and intensify the city itself as a pure spatial formation, creating an immersive sculptural field that could, ostensibly, reassert the body in the city. While it was never realized, Smith's speculative space refused the limits of the autonomous sculptural object that remained scaled to the body and dwarfed by the city. And it equally refused the politics of instrumental use. Smith's recognition of a subject with "any degree of identity that they cared to have" countered Hoving's exclusionary attempt to attract "better people" and displace "the slimiest elements of society" in Bryant Park. The humanity of Smith's open space of sculpture would reside in the openness, inclusion, and social exchange.

Even as Smith proposed a radical expansion of sculpture as a spatial field within the city, he remained grounded in the discourse of the city and in dialogue with urban and architectural critics and theorists. Smith did not envision *Project for a Parking Lot* as a decontextualized space of existential aesthetics but instead as a concrete means of reorienting the subject to an increasingly incoherent urban plan. In his conference presentation, Smith suggested that the problem with downtown Minneapolis was that the public could not perceive its form or the relation of the city center to surrounding infrastructures. Minneapolis as a whole was organized centrifugally, following the freeway system that loops around the city, Smith suggested, whereas the downtown area was organized by a grid plan. "I think of Minneapolis as being a very wide, broadly spread out ring. A ring of freeways, of course the natural elements, the lakes, rivers and parks and beyond that the suburbs. There are radial arteries going from the central city to the suburbs. . . . One doesn't feel this ring. . . . And this gives me the sense of the downtown area as being terribly empty of certain elements which are very prominent if one is traveling around in a motor car."[48] According to Smith, Minneapolis suffered from a formal and spatial disconnect between the city and its infrastructures that made it difficult for people to engage the center and, in fact, led people away from the urban core.

Methodologically, Smith's presentation in Minneapolis closely followed Kevin Lynch's classic study of urban form, *The Image of the City*, published in 1960. Lynch assessed the relative legibility of the city and the public's perception of, and orientation in, the urban environment. Objects in the city, he argued, mediate the urban subject and the environment, organize perception and knowledge, and stimulate the social. "A highly imageable (apparent, legible, or visible) city would seem well formed, distinct, remarkable; it would invite the eye and the ear to greater attention and participation. The sensuous grasp upon such surroundings would not merely be simplified, but also extended and deepened."[49] In complex urban environments, Lynch argued for the benefit of simple, repetitive, geometric forms to reinforce urban design and facilitate the public's understanding of it.[50] The key to coherent urban perception and knowledge, for Lynch, was intensity of experience within the city. Clear urban forms, he suggested, would combat the fragmentation of perception and social isolation of everyday life—the fragmentation that Smith diagnosed in Minneapolis. And, Lynch concluded, a city with a perceivable urban form could become more inclusive, tolerant, and democratic.[51] Lynch, who drew from Gestalt theories of perception, rhetorically privileged the eye in grasping the image of the city. However, this image was produced, according to his account, in an immersive, durational, and mobile experience of the body that resonated with Smith's theory of sculpture as well as the phenomenological bias of contemporaneous art criticism.

Smith and Lynch believed that the city needed symbolic and spatial elements to orient the subject and to give meaning to urban space. In Minneapolis, Smith suggested, "what must be established is some kind of force which would intensify the urban life—the lack of confrontation and centralization generally."[52] But his solution was radically different from the approach to open space in progressive critiques of urban planning. Following Lynch, Jane Jacobs, William H. Whyte, Vincent Scully, and others agreed that empty, undeveloped, and underutilized space was a significant problem for urban perception, knowledge, and social vitality. The parking lot was among the most derided urban forms, along with garbage-strewn lots and rotting piers. But Smith eschewed the conventional solutions to these vacant spaces.

Christopher Ketcham

The parking lot, for many urban critics and theorists, was a left-over space of urban renewal. For Smith, this residual space, however flawed, should not be negated. It was an essential part of postwar American life. It should not be filled with trees and made into a park or seamlessly reintegrated with the surrounding city. The parking lot should instead be honed, Smith argued, and made to serve a new humanist urbanism. "For me," Smith wrote in his published description of *Project for a Parking Lot*, "the dramatic consists in the confrontation of an individual with the most intense expression of a specific time and place. What is monumental consists in giving this expression the clearest and most economical form."[53] In *Project for a Parking Lot*, Smith embraced this residual space of urban renewal as an expression of a specific time and place and sought to clarify its form.

Project for a Parking Lot offered an intensification of the harsh open space that others sought to fill in. Rather than a new street or park, Smith proposed an uncompromising field of cold stone informed by the brutal protocols of urban renewal. There would be no pastoral or suburban softening of urban space. If one were to gain a heightened experience of the city, Smith made clear that the experience would not be comfortable. *Project for a Parking Lot* would provide no sensorial respite from the city and no place to rest. It would remain an open space that broke the frame of buildings defining the street. However, Smith rejected his own prior pastoral ideal of nature through which the discourse of open space was so often organized and with which the city was to be saved from itself. When he sought to establish a new space of urban and aesthetic experience—a new spatial field of sculpture—the parking lot, not the natural landscape, was his model. The conditions for existential enlightenment, one could say, would be shaped by the contradictions of the modern city.

Working as a sculptor, Smith entered the discourse of the city at a moment of crisis, alongside architects, urban planners, critics and theorists, and municipal politicians. This was an urgent project in the postwar American city, as highways circled the city and modernist architecture colonized the vacant spaces of urban renewal.

The opposed scales of infrastructure, architecture, and body seemed irresolvable. The humanity of the city and the meaning of urban space were endangered. In this context, Smith pursued the contradictions of urban space—the conceived, abstract shape of urban space and the perceived, concrete realities of the city; the rational geometries of the grid and the irrational social formations that cohere within a modular spatial framework; the inhumanity of modern architectures and infrastructures and their potential to accommodate social experience, the body, and the body politic. At the margin of architecture, Smith's sculpture constituted a synthesis of these opposed realities and a catalytic node in the network of urban space. The aesthetic ideals that were written around his work in Philadelphia, New York City, and Minneapolis remain a model for the work that sculpture can do in the city.[54] Positioned as a hostile interruption to the architectural programming of urban space, it can open a territorial field of embodied aesthetic experience, orient the body to the city, and disorder the spatial surround. This art history continues to meet us in the street, in public parks, and urban plazas where we confront sculpture's enduring social, spatial, and aesthetic claims.

Christopher Ketcham

1 Tony Smith, "The Pattern of Organic Life in America," 1943–45, unpublished manuscript, n.p., Tony Smith Archives.

2 Tony Smith, transcript of conference proceedings, "Hennepin: The Future of an Avenue: Two Open Forums," April 24, 1970, Reel 1A-B, 14-5, in *Project for a Parking Lot* folder.

3 Tony Smith, "Account of Career," in *Nine Sculptures by Tony Smith*, ed. E. C. Goossen, exh. cat. (Newark, NJ: Newark Museum and New Jersey State Council on the Arts, 1970), n.p.

4 Tony Smith, "On the Way to a City. Part II," unpublished manuscript, Nuremberg, Germany, 1954.

5 The key texts in the 1960s critique of the plaza include Jane Jacobs, "Downtown for People," in *The Exploding Metropolis*, ed. William H. Whyte (Garden City, NY: Doubleday, 1958), 157–58; Jane Jacobs, *The Death and Life of Great American Cities* (New York: Random House, 1961), 74, 94, 296, 495, 498; Lewis Mumford, "Yesterday's City of Tomorrow," *Architectural Record* 132, no. 5 (November 1962): 139–44; Vincent Scully, "Death of the Street," *Perspecta* 8 (1963): 95; Peter Blake, "Slaughter on Sixth Avenue," *Architectural Forum* 122, no. 3 (June 1965): 13–19; and Ada Louise Huxtable, "New York City's Growing Architectural Poverty," *New York Times*, February 12, 1968.

6 Tony Smith, quoted in Samuel Wagstaff Jr., *Tony Smith: Two Exhibitions of Sculpture*, exh. cat. (Hartford, CT: Wadsworth Atheneum;

Philadelphia: Institute of Contemporary Art, University of Pennsylvania, 1966), n.p.

7 Samuel Adams Green, "Interview with Judith Stein," in *40 Years, 6 Interviews: Institute of Contemporary Art, University of Pennsylvania*, ed. Johanna Plummer, exh. cat. (Philadelphia: Institute of Contemporary Art, 2005), 14.

8 Gregory L. Heller, *Ed Bacon: Planning, Politics, and the Building of Modern Philadelphia* (Philadelphia: University of Pennsylvania Press, 2013), 126–36.

9 Edmund Bacon, "The City Image," in *Man and the Modern City*, ed. Elizabeth Geen, Jeanne R. Lowe, and Kenneth Walker (Pittsburgh: University of Pittsburgh Press, 1963), 26.

10 Edmund Bacon, *Design of Cities* (New York: Viking Press, 1967), 21, 243–63.

11 Smith, in *Tony Smith: Two Exhibitions of Sculpture*, n.p.; and Tony Smith, "On the Way to the City. Part I," unpublished manuscript, Nuremberg, Germany, 1954.

12 Tony Smith, interview by Renée Sabatello Neu, in *Tony Smith*, exh. brochure (New York: Museum of Modern Art, 1968).

13 Tony Smith, quoted in Lucy R. Lippard, "Tony Smith: 'The Ineluctable Modality of the Visible,'" *Art International* 11, no. 6 (Summer 1967): 26.

14 Robert Morris, "Notes on Sculpture, Part 2," *Artforum* 5, no. 2

A Valid Confrontation

(October 1966): 21; Lippard, "Tony Smith: 'The Ineluctable Modality of the Visible'"; and Scott Burton, "Tony Smith and Minimalist Sculpture," lecture at the Walker Art Center (October 10, 1967), in Scott Burton, *Collected Writings on Art and Performance, 1965–1975*, ed. David J. Getsy (Chicago: Sobercove Press, 2012), 56–58.

15 Edmund Bacon, "Introduction," in *Art for the City*, ed. Samuel Adams Green, exh. cat. (Philadelphia: Institute of Contemporary Art, University of Pennsylvania, 1967), n.p.

16 Bacon, "Introduction."

17 Bacon, *Design of Cities*, 21; italics in the original.

18 Bacon, *Design of Cities*, 18.

19 Tony Smith, statement, in Wagstaff, *Tony Smith: Two Exhibitions of Sculpture*, n.p.

20 Norman Mailer, "The Big Bite," *Esquire* 60 (July–August 1963); anthologized in Norman Mailer, *Collected Essays of the 1960s*, ed. J. Michael Lennon (New York: Literary Classics of the United States, 2018), 161–70. Mailer's condemnation of modernist architecture provoked a high-profile public debate with Vincent Scully Jr., a leading architectural historian at Yale University. As a student of architecture and urban planning, Smith would likely have known of this debate. In this context, any characterization of the malignancy of modernist urban form would have been seen as an implicit reference to Mailer and Scully's dispute. See also Vincent Scully Jr., "Mailer vs.

Scully," *Architectural Forum* 120 (April 1964): 96–97.

21 Tony Smith, interview, in "Art of the Sixties: The Walls Come Tumbling Down," *Eye on Art*, CBS, 1968, https://www.youtube.com/watch?v=rqsNSprAsss.

22 Tony Smith, "Statements by Sculptors," *Art Journal* 35, no. 2 (Winter 1975–76): 129.

23 Samuel Wagstaff Jr., "Talking with Tony Smith," *Artforum* 5, no. 4 (December 1966): 14–19. Most of the sculptures in the exhibition catalogue published by the Wadsworth Atheneum and the ICA were also photographed in Smith's backyard, including ten-image spreads of both *Amaryllis* and *Willy* that gave the reader a sense of the spatial frame and the embodied aesthetic experience of the respective works.

24 Wagstaff, *Tony Smith: Two Exhibitions of Sculpture*, n.p.

25 Bacon, "The City Image," 26.

26 Hillary Ballon, "The Physical City," in *America's Mayor: John V. Lindsay and the Reinvention of New York*, ed. Sam Roberts, exh. publication (New York: Museum of the City of New York, 2010), 132–46; and Mariana Mogilevich, "Arts as Public Policy: Cultural Spaces for Democracy and Growth," in *Summer in the City: John Lindsay, New York, and the American Dream*, ed. Joseph P. Viteritti (Baltimore: Johns Hopkins University Press, 2014), 195–224.

27 [Thomas Hoving], "Parks and Recreation," White Paper, Campaign

Press Center, John V. Lindsay for Mayor, October 8, 1965, John Vliet Lindsay Papers (MS 592), Manuscripts and Archives, Yale University Library, Box 91, Folder 86.

28 Samuel Adams Green was hired by the Lindsay administration as a consultant to the Office of Cultural Affairs. Karin Bacon, Edmund's daughter, worked in the same office under Doris Freedman. August Heckscher, Lindsay's second Parks Commissioner, cited Bacon's theory of embodied spatial awareness as one of the core goals of the New York City Parks Department and Office of Cultural Affairs. See August Heckscher, *Alive in the City: Memoir of an Ex-Commissioner* (New York: Charles Scribner's Sons, 1974), 164.

29 Samuel J. Wagstaff Jr., to Thomas Hoving, November 23, 1966, Series 1.1, Box 1, Folder 27, Samuel J. Wagstaff papers, circa 1932–1985, Archives of American Art, Smithsonian Institution.

30 Thomas Hoving to Samuel J. Wagstaff Jr., December 2, 1966, Series 1.1, Box 1, Folder 27, Samuel J. Wagstaff papers, circa 1932–1985, Archives of American Art, Smithsonian Institution.

31 Barbaralee Diamonstein to Tony Smith, January 17, 1967, Thomas Hoving file.

32 [Hoving], "Parks and Recreation," 4. In this passage, Hoving quotes from Robert Zion and Harold Breen, *New Parks for New York* (New York: Architectural League of New York and Park Association of New York, 1963), n.p.

33 [Hoving], "Parks and Recreation," 12; Zion and Breen, *New Parks for New York*, n.p.

34 Gay Talese, "Cafe Is Suggested for Bryant Park," *New York Times*, June 4, 1964.

35 Edward Burks, "Hoving to Upgrade Bryant Park Area," *New York Times*, June 24, 1966.

36 [Hoving], "Parks and Recreation," 4. August Heckscher, Hoving's successor, also described the pastoral identity of New York City parks and the attempt to preserve that pastoralism at all costs. See Heckscher, *Alive in the City*, 28–29.

37 Press Release, February 21, 1967, New York City Parks Department, Thomas Hoving file.

38 The politics of gay male cruising and Bryant Park are more fully assessed in a previously published version of this essay. See Christopher Ketcham, "Tony Smith, Bryant Park, and Body Politics in John Lindsay's New York," *Public Art Dialogue* 7, no. 2 (2017): 138–59.

39 Grace Glueck, "Bringing Back Beardsley," *New York Times*, February 19, 1967.

40 [Piri Halasz], "Master of the Monumentalists," *Time*, October 13, 1967, 84.

41 Harold Rosenberg, "Defining Art," *New Yorker*, February 25, 1967, 109.

42 Hilton Kramer, "A Sculpture Show in Bryant Park," *New York Times*, February 2, 1967.

43 Michael Benedikt, "Sculpture as Architecture: New York Letter, 1966–67," in *Minimal Art: A Critical Anthology*, ed. Gregory Battcock (Berkeley: University of California Press, 1995), 89.

44 Quoted in Peter Wolf, "The Urban Street," *Art in America* 58, no. 6 (November–December 1970): 118.

45 Smith, "Statements by Sculptors," 129.

46 Smith, "Hennepin: The Future of an Avenue, Two Open Forums." See also Lucy R. Lippard, "The New Work: More Points on the Lattice," in *Tony Smith: Recent Sculpture*, exh. cat. (New York: M. Knoedler & Co., 1971), 16.

47 Smith, "Art of the Sixties: The Walls Come Tumbling Down."

48 Smith, "Hennepin: The Future of an Avenue, Two Open Forums."

49 Kevin Lynch, *The Image of the City* (Cambridge, MA: MIT Press, 1960), 10.

50 Lynch, *The Image of the City*, 105–6.

51 Lynch, *The Image of the City*, 119–20.

52 Smith, "Hennepin: The Future of an Avenue, Two Open Forums."

53 Tony Smith, "Project for a Parking Lot," in "Conceptual Architecture," special issue, *Design Quarterly*, no. 78/79 (1970): 64.

54 Smith, "On the Way to a City. Part II."

Jas Rault

Tony Smith's Queer Architectures: "the inscrutability and the mysteriousness of the thing"

I'm interested in the inscrutability and the mysteriousness of the thing. Something obvious on the face of it . . . is of no further interest. . . . [A] general suggestion of substance, generosity, is calm and reassuring—qualities which take it beyond pure utility. It continues to nourish us time and time again. We can't see it in a second, we continue to read it.
Tony Smith[1]

I have always been fascinated with what I call the invisible presence. We all have it. Everything has it . . . a room has it. And that is what I am intrigued with . . . especially when I am working. That invisible presence.
Betty Parsons[2]

Tony Smith does not tend to be included in histories of queer art and architecture. On the one hand, this is hardly surprising: by all accounts happily married to opera singer and actress Jane Lawrence from 1943

to his death in 1980, raising three daughters in the small New Jersey town where he grew up, Tony Smith is not the first candidate we might turn to for understanding queer creative works and lives in the midcentury United States. On the other hand, his life and work were strikingly bound up with an inordinate number of queers. The playwright Tennessee Williams, the only guest at the Smiths' wedding, was a close lifelong friend. The collector and curator Sam Wagstaff, notoriously closeted until meeting Mapplethorpe, was also a lifelong friend and supporter, curating Smith's first solo sculpture exhibition (at the Wadsworth Atheneum Museum of Art in Hartford, Connecticut, in 1966). One of Smith's first architectural renovation projects in New York City (1947) was the townhouse of his friend, the artist and "not-lesbian" Buffie Johnson—Sarah Schulman's term for the many upper-class white women artists of this era who had significant long-term sexual/romantic relationships with other women but never identified as lesbians[3]—including a ground-floor apartment where Williams lived with his longtime boyfriend, Frank Merlo. And most significantly, for the purposes of this essay, at least four of the ten

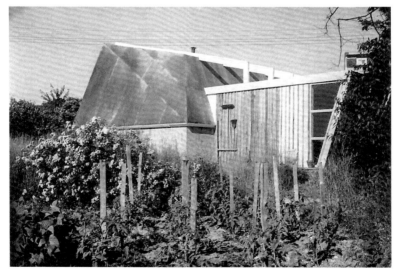

Fritz Bultman Studio, 1945, Provincetown, MA, late 1940s

houses that Smith completed were designed for queers: the painter Fritz Bultman (Studio, 1945), the painter Theodoros Stamos (House, 1951), and artist/gallerist Betty Parsons (Studio, 1960; Guest House, 1961–63).

Queerness is a notoriously complicated framework to invoke in considerations of architecture, and especially in discussions of people who lived before and in many ways beyond its use as a category of identity. Fritz Bultman was heterosexually married to Jeanne Bultman for forty-two years, but she seems to have known about, and after his death supported scholars in writing about, his "struggle with homosexual desire";[4] Stamos's sexuality and long-term boyfriends were known by at least his close friends, including Tony and Jane Smith, and perhaps more widely, given the homophobic critical reception of his work;[5] Parsons was a lesbian but, somewhat miraculously for someone with such a long and public career, managed to keep her relationships with women quite private. While there is no unequivocal evidence explicitly linking their architectural desires with their nonheterosexual desires, if we fail to consider the ways these desires

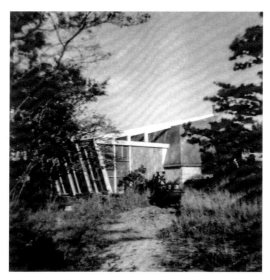

Fritz Bultman Studio, 1945, Provincetown, MA, late 1940s

informed each other we continue to misunderstand key elements of queer architecture, as well as Tony Smith's contributions to imagining and creating space for a range of sexual, gender, and relational potentialities.

Over the past thirty years or so, there have been many scholarly attempts to answer the deceptively simple question, what is queer architecture? Part of the pleasure of these attempts, for me, is that there is no good answer—no clear formulas, no stable styles, or signifiers by which we can define or even identify queer architecture. Indeed, as Marko Jobst and Naomi Stead suggest, part of what might characterize queer architecture is a tension between form and formlessness: if queer is "celebrated for its elusive, slippery nature, for being resistant to pinning down and far-reaching in its political potency . . . the implicit destabilizing it invokes seem[s] to run against [architecture's] imperative for stability and permanence."[6] Whether as verb or noun, queer can name the mutability of things—objects, borders, bodies, genders—that so many techniques of social control, including architecture, are meant to stabilize. Rather than concede to these illusions of stability, Regner Ramos and Sharif Mowlabocus understand queer architecture as one of many "sites [that] extend beyond quantifiable spaces, clickable hyperlinks, scrollable apps, and sentient bodies, to include and in fact be constituted by the *relations* between them."[7] That is, one way we might understand the queerness of architecture is by attending to the relations that a building draws on and activates—relations that make it meaningful in particular times and contexts; modes of relating to oneself and others that it can enable and disable.

In my work on early twentieth-century Sapphic modernity, I suggest that Eileen Gray and her contemporaries worked on and in architecture to cultivate possibilities for gender, sexuality, and relationality that were neither heterosexually overdetermined nor what we might now call simply lesbian.[8] The end of the nineteenth and early part of the twentieth century, in western Europe and the Anglo-Americas, was a crucial moment in what Michel Foucault characterizes as the modernization of sexuality, or what Heather Love calls the "coming of modern homosexuality," where a range of gender and

sexual experimentations and possibilities were in the process of being reduced to the kinds of knowable identities that we recognize today—homosexual, heterosexual, gay, lesbian (though, of course, the multiple terms and limited concept of sexual identity did not stabilize until much later in the twentieth century, around the time Smith was building the Bultman, Stamos, and Parsons projects).[9] This was also a crucial time in the coming of modern architecture, which came to be concerned with designing not only new buildings but also new ways of living, new relationalities, bodies, and identities. That is, at around this time, architecture joined "the great family of technologies of sex,"[10] or as Preciado puts it, architecture came to assume its biopolitical function "as a normalizing, genderizing and racializing force."[11] It should come as no surprise, then, that during this critical juncture Gray and many of her assigned-female-at-birth contemporaries turned to architecture and interior design as means by which to cultivate genders, sexualities, and relationships far beyond the limiting expectations of white heterofemininity, or what for them seemed like the equally limiting expectations of an emerging modern homosexual identity.

The studios/houses that Smith designed for Bultman, Stamos, and Parsons were all built well before the 1969 riots at a little West Village bar called Stonewall, when normalized police brutality was perhaps the least of the social, economic, and legal consequences of being gay/lesbian/trans in New York City (and the United States). The celebration of a particularly virulent form of white heteromasculinity, fortified by misogyny, homophobia, and racism, was certainly not unique to the artists and artistic milieu of abstract expressionism with which it has so often been associated. The political, economic, and social apparatuses of New York's art worlds, no less than that of the United States more broadly, were increasingly desperately invested in inventing and enforcing protective boundaries around whiteness, heterosexuality, and the compulsory phantasm of binary gender: homosexuality was illegal, dressing as the "wrong" gender was illegal, white lives and hoarded resources were protected by segregation laws and redlining practices, and the violent illusion of white purity was bolstered by anti-miscegenation laws. In its role

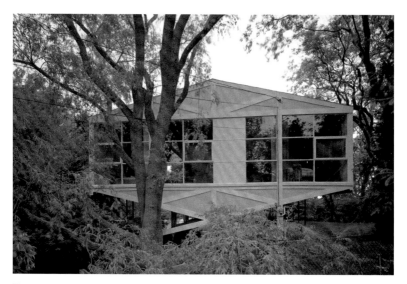

Theodoros Stamos House, 1951, East Marion, NY, 1993

as a biopolitical technology, Smith's architecture entered into volatile debates about gendered, racialized, and sexual capacities and potentialities of bodies.

Smith's projects for these three clients were all retreats, removed from the rhythms, expectations, and patterns of urban and domestic life. For all three, this meant a remove from Manhattan and the everyday demands of their professional and entwined social lives. While the Stamos House and the Parsons Studio and Guest House were designed to accommodate personal and creative lives that were already removed from hetero-domesticity—that is, for two clients who did not enjoy the cover of heterosexuality—from its inception, the Bultman Studio occupied a more complex relationship to sexuality. The studio—something of an irregular parallelogram; as Smith puts it, "one side of the building is about 4 feet below the surface," with the other side made up of a leaning wall of glass windows— is on the same property but down the hill from the house he shared with Jeanne and their two kids in Provincetown, Massachusetts.[12] Conceived as a wedding present from Smith, the studio seems to

Jas Rault

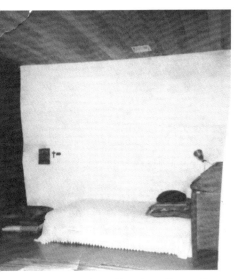
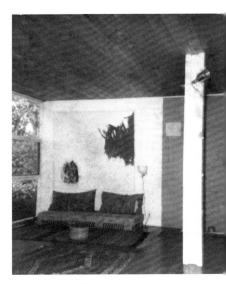

Interior views, Theodoros Stamos House, 1951, East Marion, NY, 1957

reflect and accommodate an experimental/creative step away from hetero-domesticity exactly at its foundation. Rather than gifting the Bultmans, say, an extension to their one-room "garden shack" — with conventional postwar expectations and obligations that marriage lead immediately to children — Smith began work on a separate space for Fritz to paint in.[13]

The studio was also, it seems, a wedding gift as group project. In a 2004 interview publicizing a retrospective of Fritz's work at the Albert Merola Gallery in Provincetown, Jeanne Bultman recalls that while Fritz and Smith collaborated on elaborate conceptual plans for the studio, and sourced the wood from an old Truro barn, "neither one could put a nail in board and actually pound it."[14] By 1945, Fritz had been studying with Hans Hofmann, who was living in Provincetown with his wife Maria, hosting an increasingly popular summer art school, through which Jeanne and Fritz had met and which shaped the careers of many of the "Irascibles." As Jeanne remembers it, "Miz [Maria] Hofmann 'got up on a scaffold — it had a very high ceiling and painted the whole thing white inside. She was

wonderful!'"[15] Apparently, the first occupants were the Hofmanns, as Hans ran his summer school under the same high ceiling that Maria had painted. While an undisturbed space for the serious business of man-thinking has been and may well still be understood as the prerogative and privilege of (white) heteromasculinity,[16] there is something to this studio's irregular design that suggests and enables irregular and capacious intimacies.

In photographs, the Bultman Studio looks at first like a bunker, all trapezoidal roof-cap, sunk into the land, wrapped by trees and climbing gardens. But when I study the sketchy plans, consult the very helpfully precise model, look more closely at the photos, and search around for written accounts, I begin to see, or to understand, that the largest surface is an upwardly inclining wall of windows. In a recent account of the current inhabitant Rob DuToit's experience of the space, I learn that these windows are the defining feature of the studio: "a tall, vaulted space with north-facing windows that allow [DuToit] to work under natural light alone. 'It's amazing! It's never dark in here.'"[17] This wall of light, emerging from the surrounding landscape, comes up again in Ron Shuebrook's memories of his first visit to the studio (in the mid-1970s):

> As I entered the light-filled studio, I was immediately struck by how this dynamic, interior space seemed to be a meeting place between the natural and the built environment. Consequently, it was not surprising to be later reminded by Fritz that Tony Smith had studied with Frank Lloyd Wright, the master of environmentally integrated architecture. With its self-evident, utilitarian construction and its angled bank of floor-to-ceiling windows, this deceptive building offered not only physical and psychological shelter but also an intimate view of the surrounding foliage and landscape. It seemed a perfect context for making art that was not only based on a need for individual invention but also on the persuasions of cultural and geographical circumstance.[18]

The influence of Wright on Smith's work, its sunken integration with the land, comes through in the photographs, but the impression

it affords of "physical and psychological shelter," combined with the surprising wall of light, are elements not easily pictured, or perhaps deliberately obscured. From what I can find, there are only one or two interior photographs of the space, with Fritz posed next to canvases, and only one provides a hint of this combined shelter and endless light (reproduced in the Shuebrook article).[19] This was not a space to look at. This was not even a space to look out from. This was designed as a removed, highly protected experience of creative inhabitation; its most striking and enlivening feature, its opening to light, was also its most private.

From within this private, light-filled cavern, Bultman turned and more tightly tangled his thoughts, sketches, studies, and paintings around mythology and sexuality. In a short memoir recalling the close friendship of Provincetown neighbors Myron Stout and Fritz Bultman, Michael Stephens recounts Jeanne's reflections that "since Fritz and Myron are gone . . . there is no one to carry on those conversations that they used to have about Greek art, mythology, and the classical world."[20] Stephens suggests that part of Stout and Fritz's friendship was shaped by being "lapsed Catholics"[21]—a bond perhaps shared with Smith himself, who had his own keen critique of what he called "the problems of Christianity and democracy"[22]—but these rumi-nations on Greek art and mythology might best be conjured in the campy spirit that Stephens remembers from Fritz, his "lacerating wit, sense of high camp—oh the way he could lash into someone begin-ning with the word, 'Honey,' and then lambast away—and an abiding dedication to irony."[23] When art historians turn to Fritz's working and reworking of the myth of Actaeon—the deer hunter turned, by Artemis, into a deer as punishment for his illicit lustful gaze—in his notebooks, sketches, and many paintings, especially those completed in his studio from 1945 to '49 (culminating in *The Hunter*), we might do well to leaven his agonized "homosexual inclinations" with this high camp "Honey."[24] Perhaps his ruminations on Actaeon's fate in "the cauldron of homosexuality" become slightly less tragic and more pleasurably lacerating when conjured under that studio's secret wall of light; as Bultman put it, "Curiosity killed the cat, rat ta tat tat, poor dear, poor deer."[25] Built for and within a dynamic of sexuality that

seems to have been more capacious and undisciplined than our contemporary imaginations want to allow—both within and beyond the hetero-domesticity he built with Jeanne, the Hofmanns, Stout, and Smith; at once visible and submerged, removed and integrated, (en)closed and not-so-secretly very open—this studio strikes me as the kind of boundary-blurring low camp that enabled Fritz Bultman's social, sexual, and artistic orientations.

The house that Smith built for Stamos is not nearly so low, and orients to a very different sort of light remove. By 1951, Stamos had gained notoriety not only for his softly surreal abstract paintings—his first solo show was at Betty Parsons's gallery in 1947—but particularly for his association as the youngest signatory of the famous "open letter" to the president of the Metropolitan Museum of Art (1950) and his dashingly disheveled front-row seat in a *Life* magazine photo announcing the new New York School of "Irascibles" in January of 1951. As the youngest, certainly the most working-class, a second-generation Greek from New York's Lower East Side, we cannot be sure how open his secret of homosexuality would have been. But, like Alfonso Ossorio—first-generation Filipino, another gay artist whose career was launched by Betty Parsons—we can assume "there was no question that it was difficult to be gay in the late forties."[26] When Smith turned to the design of Stamos's house, he was in the midst of an ambitious but ultimately disappointing project with Ossorio and Jackson Pollock, designing a Roman Catholic church that "consisted of a dozen nested hexagonal units raised off the ground on upright supports, with a thirteenth satellite hexagon covering the baptistry and connected to the main edifice by a walkway."[27] This antihierarchical design was, perhaps unsurprisingly, rejected by the church board, but we can see the ways that it informs the Stamos House.

This elongated single hexagon, hovering above the ground on a cross-hatched cantilevered base, features both front- and back-facing walls of glass in rectangular frames, echoing the rectangular living space framed by decorative trusses, which in turn echo the foundational pilotis. At first glance, this house is a stark formal departure from the Bultman studio—raised off the ground rather than integrated into it; window walls perched on a cantilevered frame, overseeing rather than

engaging the land, more Le Corbusier than Wright in offering a view-ing platform rather than an organic extension of its environment. As John Keenen notes, this house is built from the principle of a modular system, but instead of "the repetition of many cells," it demonstrates "the perfecting of a singular cell."[28] With Stamos's painting and artistic associations bringing him increasing public attention—as Ann Gibson notes, "critic[s] cast his work in the same negative codes used to denounce homosexuality,"[29] including Clement Greenberg famously writing off Stamos's 1947 show as derivative and "sickeningly sweet"[30]—Smith seems to have created exactly the kind of serene remove, outside and above the intensifying fray, that Stamos needed.

But it would be a mistake to assume that this was designed or used as a house for Stamos alone. At around the same time that the first mass, modularly designed suburban developments were being built further down Long Island in Levittown—to house the postwar push to segregated white heterosexual reproduction[31]—Smith designed a house with a small single bedroom, a study of the same size, a living room the stretch of those two together, slightly divided by a small kitchen, bathroom, and storage room, all sand-wiched in glass. This was neither the uninhabitable, and perhaps misogynist, Farnsworth glass house by Mies van der Rohe (1951)[32] nor the decorative Glass House, with discreetly hidden queer bunker, by Philip Johnson (1949).[33] But this was also by no means a family house of the sort being rapidly erected around the United States at that time, with their hetero-colonial-antebellum "master" bedroom, two children's bedrooms, and single window wall in/as TV room.[34] From the earliest moment it was habitable—well before the stairs to the raised front door were built, and the house accessible only by a builder's ladder—Stamos lived and worked at this house, most often with his partner, Robert "Bob" Price, until Price's death (in 1954), and again later with partner Ralph Humphrey.

It is from their letters to Smith, from Stamos but especially from Price, that I can best glean the lives and relations that this house enabled. Again, there are very few photographs of the house's interior: one example suggests a monastic-looking room with a single, unframed bed on the floor (a small cross among several other

indistinguishable items on the wall above);[35] another photo shows a room with an improvised settee of sorts—perhaps converted from the simple bed, throw pillows propped against the wall—with two richly woven rugs of different patterns but colors complementary to the large painting hung behind, likely Stamos's *White Field, No. 2* (1957), included in the Museum of Modern Art's landmark exhibition *New American Painting* (1958), which toured Europe before being shown at MoMA in 1959.[36] Indeed, the five pieces included in that show are dated from 1952 to 1958 and may well have been painted at the house. While neither Stamos nor Smith refer to the house as a studio, it is clear from their letters that Stamos used the structure as a combined live-work space. In an undated, stream-of-consciousness letter from Price (probably written in 1953–54, when the Smiths were in Germany, as he closes with "kisses around to the Smiths of Nurmberg [*sic*]"), we get a sense of the intimacy between the Smiths, Stamos, and Price, as well as the kinds of pleasures the house facilitated:

> A Japanese painter said the house combines the singular and the plural. I still like what the Greek man said, "The house is all health." Stamos has had a good painting summer. . . . You mention despondency. I just wish you had the opportunity to build more. The thing you can't see or can't know about being so far away is the great joy this building gives to people. There is something wonderful happens when they step in the door. Their expression changes. It is something immediate & pure as if they had suddenly caught a wonderful and new fragrance. It is the odor of tuberoses blooming beneath the window. A beautiful woman came and sat with us for a few hours Sunday afternoon. She kept saying, "It is so relaxing. This is a housekeepers dream." Only one person hasn't reacted and she was something special. She was a gorgeous Greek woman, a friend of sweet, giddy Alice down the road. Alice kept wanting her to see the house. She wasn't interested. She said, I don't go places to look at things. I go to be with people. She sat as if we had all met in the

desert. Stamos put on his Greek records and she was happy. . . . The woods are full of them that loves ya. Take heart. Can't you hear our voices on the wind? Oodles of Tony ceremonies are still observed.[37]

While I'm unsure what these "Tony ceremonies" might have been, I like to imagine they would involve collecting and luxuriating in the different forms of "great joy" that Price recounts here. The national, racialized, and gender markers—Japanese painter, Greek man, Greek woman—may be an effort to communicate the universal appeal of the house, and the terms of this praise would all have been queerly sexualized in the 1950s: the "beautiful woman" who relaxes in the dreamy ease of gendered labors, a happiness engendered not from visual pleasures alone ("I don't go places to look at things") but from the "immediate and pure" sensual enhancement of new relationalities ("'I go to be with people' . . . and she was happy"); the pleasurable "combination of singular and plural" which is "all health." During this heyday of the Lavender Scare, when everything from the US government to the first *Diagnostic and Statistical Manual of Mental Disorders* was equating homosexuality with criminal antisociality—Joseph McCarthy gave his famous Senate hearing speeches in 1950 conflating homosexuals and communists as national security risks; in 1952, the *DSM* classified homosexuality as a pathological "sexual deviation"[38]—the suggestion that the Stamos House created joyous sensual experiences that were somehow universal, at once social, healthy, pure, "singular and plural," would have resonated with and against the anti-gay rhetoric at the time. Given the closeness of Smith's friendships with Stamos and Price, and the increasingly public discourse around homosexuality as a threat to white nationalist security, I like to believe that these queerly coded pleasures would indeed have helped to lift Smith out of his "despondency" and encouraged him to "build more."

Smith's next major architectural project would be a Studio (1960) and Guest House (1961–63) in Southold, New York, on Long Island's North Fork, for the formidable curator, gallerist, and artist Betty Parsons—a woman who carefully and deliberately protected

her privacy. An unusually forthcoming interview with Helène Aylon, one of the artists Parsons represented, was meant to be published in the special issue of *Heresies* on "lesbian art and artists,"[39] but instead came out in two excerpts, one in a 1977 issue of *womanart*[40] and the other in a 2013 issue of *Art in America*, where Judith Stein explained, "their conversation never appeared in *Heresies* because the 77-year-old dealer, who had been open about her sexuality in her youth, now guarded her privacy."[41] Indeed, from this interview we get a sense of the gendered, erotic, and aesthetic importance of privacy for Parsons. She reflects on having had "so many boring males around me. They were athletic, rich and aggressive and they were insensitive. I didn't like any part of it."[42] She follows this with the comment, "Oh, I've had plenty of crushes on women," to which Aylon asks, "Did you worry about people finding out about it?"[43] Parsons's answer and their exchange is worth quoting at length:

> PARSONS: I was always discreet. I was brought up in a very New England [type of] background, where you never showed to the public what you felt. I remember my mother saying to me when I was in my teens, "Betty, it doesn't much matter what you do, but *never* get found out."

> AYLON: The whole new attitude is "let it all hang out." It's good not to be controlled.

> PARSONS: Well, that can be overdone, too, though. I believe in a certain amount of privacy that creates a tension that's important. I believe in tension. If you're painting a picture, and it has no tension, it has no excitement. Love creates tension because you have no idea if you're going to please or not please. Tension enhances life.[44]

I read this as a statement on the Sapphic erotics of privacy. While Parsons is not excited about "the whole new attitude" of

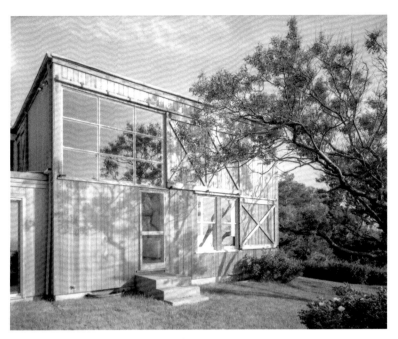

Betty Parsons Studio, 1960, Southold, NY, 1993

outness, we would be mistaken to read her reservations as rejections of queer gender, and of sexual and aesthetic excitement. Indeed, later in the interview, she talks about getting "tremendous nourishment from women," of having "lots of male in me," explaining that "a rounded person will have both [male and female]," and praising what she sees as the "world now becoming androgyn."[45] These queer "enhancements" of love, life, and art seem intimately entwined with her cultivation of the "tension" of privacy.

Given the duration and closeness of their friendship,[46] we can assume that Smith was not one of the "boring" men that Parsons refers to above, and that he was attuned to the complex privacies that she needed from her Southold studio and guest house. Smith struggled with depression, and this may have delayed his work on the projects—we can see a letter from October 1959, where Barnett Newman writes to Smith about his recent visit with Parsons:

This is just a line to tell you that I did not raise the issue of your inability to get started on her house—but she did ask about you and Jane and that her eagerness, I felt, was only to see you so that you both could talk house. . . . I think she would not even consider anyone else for her house. . . . Finally Tony, if you don't do the house for her whenever you are ready it will be a terrible blow to her. My impression was that she was agreeable to anything in order to have you do it.[47]

While Newman takes on the roles of messenger and confidant here, Smith seems to have been candid with Parsons about his health—"I am sick with fatigue and practically insane with depression"—and despite the delays, Parsons would neither consider nor trust anyone else with this project.

Not unlike the Bultman Studio and Stamos House, there is very little in the archives about the design process—there are several provisional sketches but very little correspondence, so it is unclear how collaborative the designs were, or whether Parsons was indeed

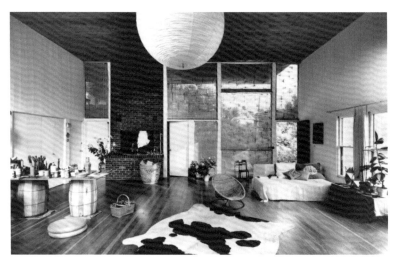

Interior view, Betty Parsons Studio, 1960, Southold, NY, 1965

"agreeable to anything," and existing photographs focus mostly on the built exteriors of both the Studio and Guest House. Unlike the Bultman and Stamos projects, however, the model for the Parsons Studio seems to bear almost no resemblance to the final construction. The model suggests a very Corbusian house (not unlike the Villa Stein, 1927), with solid white exterior walls (perhaps concrete), two thin bands of horizontal strip windows on one side, and one low bank of windows on the other, an angled skylight, and a walled-in concrete patio. The final studio, on the other hand, is a study in repurposed wood and irregular windows that suggests a New England barn-cum-refuge more than it does a *machine à habiter*.[48] The windows that make up most of the walls are an unusual mix of sizes and shapes, from one raised bank above an entry door—nine rectangular panes comprising one high window—to a patchwork of horizontal and vertical panes stitched together by vertical plywood finishing and barn-style doors, sliding along horizontal metal guides. Shades for the windows seem to have been important for Parsons, as those without the heavy exterior sliding doors were retrofit with adjustable hanging coverings, perhaps bamboo.[49]

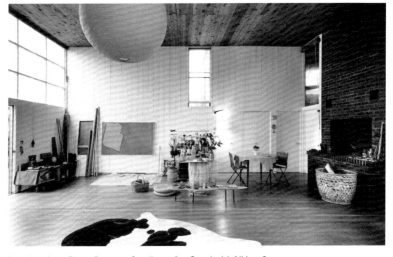

Interior view, Betty Parsons Studio, 1960, Southold, NY, 1965

The mix of horizonal and vertical orientation may have been an improvised result of using what was at hand, but the result suggests a critical intervention in the modernist architectural investment in strip windows. As Beatriz Colomina explains in *Privacy and Publicity*, Le Corbusier's promotion of horizontal strip windows reflects his refusal of embodied inhabitation and his eager architectural embrace of new media technologies—orchestrating views that cut and frame the exterior world as through a camera. As Colomina puts it, for Le Corbusier, "the house is a system for taking pictures," where domesticity and interiority are replaced by the inhabitation of a mobile view, and the old style of vertical windows keeps an inhabitant mired in a fleshy, feminized earthiness that modernist architecture associated with pathologies, from tuberculosis to homosexuality.[50] The Parsons Studio, not unlike Eileen Gray's architecture, offers a combination of these ideologically loaded signs that may well have appealed to someone navigating the pressure of publicity and modernity with the eroticized pull of privacy.

The photos of the studio's interior show us an active live-work space. The images seem designed to communicate an artistic workspace uninterested in conventions of domesticity or sociality. We see light, mobile, and improvised (DIY) furnishings—woven bamboo chairs in thin wire frames, wicker baskets, long low table-benches slung over with fabrics, wooden barrel legs for a large tabletop covered in painting materials, a low couch (that might fold out into a bed?), and a frameless bed with pillows and draped in pale linens. Parsons was there every weekend, explaining, "That's where I work. And I work like mad."[51] One image includes a small table, including tablecloth and a piled bowl of fruit, with two folding wicker chairs, the only suggestion of sociality.[52] We have no photographs of the kitchen or bedroom (if there even was a bedroom). These are images of her most private interior space that give very little away, that protect and cultivate the tension of privacy. To me, these are images full of what Parsons called "invisible presence."[53]

The tension of this invisible presence is more pronounced when we consider the Parsons Guest House. Commissioned from Smith shortly after her studio was built, we have even less documentation

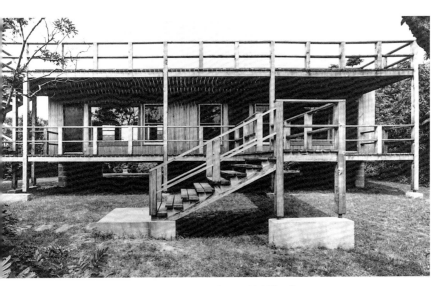

Betty Parsons Guest House, 1961–63, Southold, NY, 1965

of this project. It seems to be a simple rectangular structure, raised on brick pilotis, hung with windows running the length of both sides, and finished with vertical wood siding to echo the studio up the hill. The photographs focus on the elaborate wooden stair system, climbing first to a small bridge that elongates the passage to a deck leading to the main door, and climbs again to a sort of rooftop patio. The façade of the Guest House is entirely obscured by decks that stretch the length of the main floor and rooftop. Clearly, Parsons intended to have guests at Southold—but equally clearly, she did not intend her studio as—or to be *known as*—a space for guests to share. Whether or not she had lovers or other "nourishing" women at her place, the Guest House—protected and provided with independent indoor and outdoor space—serves as excellent cover. To echo the advice from her mother: "it doesn't much matter what you do, but *never* get found out."

All three of these buildings speak to me of the kind of nourishing "inscrutability" that Smith valued in his work, and that tends to be associated more with his sculpture than his architecture.

I think that we can see in the Bultman Studio, Stamos House, and Parsons's Studio and Guest House some of the experiments in space-making that informed Smith's monumental abstract sculptures. These are buildings that "suggest a calm and reassuring substance"—a refuge removed from the expectations of heterosexuality—but that also go beyond "pure utility" to accommodate a mysteriousness that was as nourishing for Bultman, Stamos, and Parsons as it was necessary.[54]

1 Tony Smith, quoted in Samuel Wagstaff Jr., "Talking with Tony Smith," *Artforum* 5, no. 4 (December 1966): 18.

2 Betty Parsons, quoted in Hélène Aylon, "Interview with Betty Parsons," *womanart* 2, no. 1 (Fall 1977): 12 (ellipses in original), https://www.womanartmag.org/issue/fall-1977.

3 Sarah Schulman, "Making Lesbian History Possible: A Proposal," in *Imagining Queer Methods*, ed. Matt Brim and Amin Ghaziani (New York: New York University Press, 2019), 299.

4 Evan R. Firestone, "Fritz Bultman: The Case of the Missing 'Irascible,'" *Archives of American Art Journal* 34, no. 2 (1994): 11–20. See also Ann Gibson, *Abstract Expressionism: Other Politics* (New Haven, CT: Yale University Press, 1999).

5 See Gibson, *Abstract Expressionism*; and Ann Gibson, "Lesbian Identity and the Politics of Representation in Betty Parsons's Gallery," *Journal of Homosexuality* 27, no. 1–2 (1994): 245–70.

6 Marko Jobst and Naomi Stead, eds., *Queering Architecture: Methods, Practices, Spaces, Pedagogies* (London: Bloomsbury Visual Arts, 2023), 3.

7 Regnar Ramos and Sharif Mowlabocus, eds., *Queer Sites in Global Contexts: Technologies, Spaces, and Otherness* (London: Routledge, 2020), 8, emphasis in original.

8 Jasmine Rault, *Eileen Gray and the Design of Sapphic Modernity: Staying In* (New York: Routledge, 2017).

9 Heather Love, *Feeling Backward: Loss and the Politics of Queer History* (Cambridge, MA: Harvard University Press, 2007), 4.

10 Michel Foucault, *The History of Sexuality*, vol. I: *An Introduction*, trans. Robert Hurley (1976; New York: Vintage Books, 1990), 119.

11 Beatriz Preciado, "Architecture as a Practice of Biopolitical Disobedience," *Log*, no. 25 (2012): 121.

12 Lucy R. Lippard, "Tony Smith: Talk About Sculpture," *Art News* 70 (1971): 48.

13 Susan Rand Brown, "Fritz Bultman in Provincetown," *Provincetown Banner*, July 1, 2004, 27.

14 Brown, "Fritz Bultman in Provincetown," 28.

15 Brown, "Fritz Bultman in Provincetown," 28.

16 The association between (white) masculinity and the entitlement to private space—or, as Virginia Woolf put it, "a room of one's own"—has been widely discussed in architectural studies, literary studies, geography, sociology, and gender and sexuality studies. For more on the gendered privilege of privacy—in and outside of domestic space—see Victoria Rosner, *Modernism and the Architecture of Private Life* (New York: Columbia University Press, 2005); Gülsüm Baydar and Hilde Heynen, *Negotiating Domesticity: Spatial Productions of Gender in Modern Architecture* (London: Routledge, 2005); Beatriz Colomina and Jennifer Bloomer, eds., *Sexuality and Space* (New York:

Princeton Architectural Press, 1992); and Jane Rendell, Barbara Penner, and Iain Borden, eds., *Gender Space Architecture: An Interdisciplinary Introduction* (London: Routledge, 2000).

17 Andre Van Der Wende, "Rob DuToit's Off-Kilter, Modernist Workspace: Painting in the Shadow of Fritz Bultman," *Provincetown Independent*, December 15, 2021, https://provincetownindependent.org/arts-minds/2021/12/15/rob-dutoits-off-kilter-modernist-workspace/.

18 Ron Shuebrook, "Fritz Bultman Remembered," *Provincetown Arts* (1994): 85.

19 Shuebrook, "Fritz Bultman Remembered."

20 Michael Stephens, "Fritz Bultman and Myron Stout: A Provincetown Memoir," *Provincetown Arts* (1996), 48.

21 Stephens, "Fritz Bultman and Myron Stout," 49.

22 Tony Smith, quoted in John Keenen, "Architecture," in *Tony Smith: Architect, Painter, Sculptor*, ed. Robert Storr (New York: Harry N. Abrams in association with the Museum of Modern Art, 1998), 45.

23 Stephens, "Fritz Bultman and Myron Stout," 49.

24 Firestone, "Fritz Bultman."

25 Fritz Bultman, quoted in Firestone, "Fritz Bultman," 14.

26 Alfonso Ossorio, quoted in Gibson, *Abstract Expressionism*, 17.

27 Robert Storr, "A Man of Parts," in Storr, *Tony Smith: Architect, Painter, Sculptor*, 16.

28 Keenen, "Architecture," in Storr, *Tony Smith: Architect, Painter, Sculptor*, 44.

29 Gibson, *Abstract Expressionism*, 18.

30 Clement Greenberg, quoted in Gibson, *Abstract Expressionism*, 17.

31 For more on the development of postwar suburban architecture in the United States as an investment in heterosexual whiteness, see Lynn Spigel, "The Suburban Home Companion: Television and the Neighborhood Ideal in Postwar America," in *Welcome to the Dreamhouse: Popular Media and Postwar Suburbs* (Durham, NC: Duke University Press, 2001), 31–59; and Dianne Harris, "Race, Class, and Privacy in the Ordinary Postwar House, 1945–1960," in *Landscape and Race in the United States*, ed. Richard Schein (New York: Routledge, 2006), 127–55.

32 See Alice T. Friedman, *Women and the Making of the Modern House: A Social and Architectural History* (New Haven, CT: Yale University Press, 2007), and Jasmine Rault, "Window Walls and Other Tricks of Transparency: Digital, Colonial, and Architectural Modernity," *American Quarterly* 72, no. 4 (December 2020): 937–60.

33 See Friedman, *Women and the Making of the Modern House*.

34 "While in 1950 only 9 percent of all American homes had a television set, by the end of the decade that figure rose to nearly 90 percent, and the average American watched about five hours of television per day" (Spigel, "The Suburban Home Companion," 33). See also Lynn Spigel, *Make Room for TV: Television and the Family Ideal in Postwar America* (Chicago: University of Chicago Press, 1992); and Lynn Spigel, *Welcome to the Dreamhouse: Popular Media and Postwar Suburbs* (Durham, NC: Duke University Press, 2001).

35 See photograph labeled "Stamos_1951_12," Tony Smith Archives.

36 See photograph labeled "Stamos_1951_11," Tony Smith Archives.

37 Robert Price to Tony Smith, undated (ca. 1953–54).

38 *Diagnostic and Statistical Manual of Mental Disorders*, or DSM, 1st edition (Washington, DC: American Psychiatric Association, 1952), 38–39.

39 Cynthia Carr et al., eds., "Lesbian Art and Artists," *Heresies: A Feminist Publication on Art and Politics* 1, no. 3 (1977).

40 Aylon, "Interview with Betty Parsons," 10–21.

41 Betty Parsons and Helène Aylon, "The Parsons Effect," ed. Judith Stein, *Art in America*, November 1, 2013, https://www.artnews.com/art-in-america/features/betty-parsons-62992/.

42 Betty Parsons, quoted in Aylon, "Interview with Betty Parsons," 13.

43 Parsons's comment about "crushes on women" was published in both the 1977 *womanart* and 2013 *Art in America* excerpts, but the question about "worry" was only included in the 2013 publication.

44 Parsons and Aylon, "The Parsons Effect."

45 Betty Parsons, quoted in Aylon, "Interview with Betty Parsons," 14.

46 Smith and Parsons had been friends for at least fourteen years by the time he began work on her studio in Southold, Long Island—Smith had helped install the first show at the Betty Parsons Gallery in 1946—and it seems their friendship continued until his death in 1980. They were close enough that Smith could be candid about the delays with her studio, writing: "Dear Betty, I am sick with fatigue and practically insane with depression. There doesn't seem to be anything I can do about it at present. I'll send the drawings and specifications as soon as I can get myself and them together. Love, Tony" (Tony Smith to Betty Parsons, undated). After Smith died, Parsons read a poem at his memorial, which I have not yet been able to find, but Jane Smith wrote to thank her and request a copy: "Dear Betty, You'll never know how much it meant to me to have you speak at the memorial. Your poetry and imagery were beautiful. Your presence, dignity and sincerity were deeply moving. Everyone I spoke to felt the same. You added immeasurably to the occasion. Would love to have a xerox of what you said. Love, Jane" (Jane Smith to Betty Parsons, October 24, 1981).

47 Barnett Newman to Tony Smith, October 1, 1959.

48 See Le Corbusier, *Vers une architecture* [Toward an architecture], first published in 1921 as essays in the magazine *L'Esprit Nouveau*, collected and published in book form in 1923.

49 See photograph labeled "ParsonsStudio_002," Tony Smith Archives.

50 Beatriz Colomina, *Privacy and Publicity: Modern Architecture as Mass Media* (Cambridge, MA: MIT Press, 1994), 311.

51 Parsons and Aylon, "The Parsons Effect."

52 See photograph labeled "ParsonsStudio_JonNaar_019," Tony Smith Archives.

53 Betty Parsons, quoted in Aylon, "Interview with Betty Parsons," 12.

54 Tony Smith, quoted in Wagstaff, "Talking with Tony Smith," 18.

Marta Kuzma

The Olsen House, Old Quarry, Guilford, Connecticut

The Prompt

A modest summer residence with a kitchen, bedroom, bath, and large studio with accompanying guest house.

The Response

A cave, a tent, a treehouse.

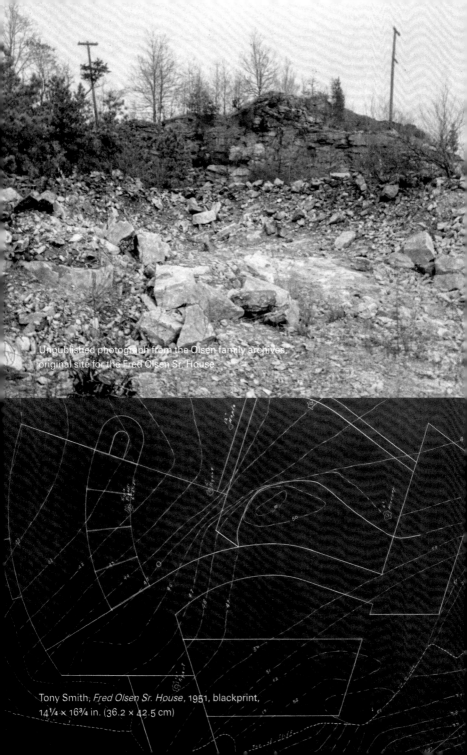

Unpublished photograph from the Olsen family archives,
original site for the Fred Olsen Sr. House

Tony Smith, *Fred Olsen Sr. House*, 1951, blackprint,
14¼ × 16¾ in. (36.2 × 42.5 cm)

Box 264,
Alton, Ill.,
March 2, 1951.

Dear Mr. Smith,

In connection with my husband's recent conversation with
you concerning the design of a house to be constructed on
the lower lot at Old Quarry, we have arrived at the follow-
ing ideas of our needs.

A studio with a fireplace, built in storage space, and pro-
visions for proper light for night time painting.
A spacious living room with wall space for three large
paintings, the largest being four feet by six feet.
Also, provisions for a corner spot for an amplifier
speaker and four feet of wall space. With outlook
into and interconnected with the living room there
should be an area in which a desk and files can be
located.
A small dining area incorporated in the living room area.
A kitchen connecting with or opening to the dining area, the
kitchen to be non-clinical in appearance.
Two bedrooms with one bath. A dressing area is not essential.
Sitting space in one bedroom is desirable
The house should be an all year round house. It would be de-
sirable to design with the possible addition of two
bedrooms and a playroom at some later date in mind.
Air conditioning is not necessary but air circulation
is important. A well, a septic tank, garage space
for two cars, and possibly laundry space will be need-
ed.

In choosing I would like to add that we were extremely impressed
with the sketch for the house on the top lot and that I will
be looking forward to discussing with you the above ideas
soon.

Sincerely yours,

Betty P. Olsen

Betty Olsen letter to Tony Smith, March 2, 1951

1
Grammar and Form

Original site for house

Tony Smith, Sketchbook #18, 1945,
each page 9¾ × 7½ in. (24.8 × 19.1 cm)

Original site for house

House as the American Clipper Ship

Tony Smith,
Sketchbook #18, 1945

The forms of the architecture of
the present are analogous to those of
musical instruments of the past.
Tony Smith, Sketchbook #18, 1945

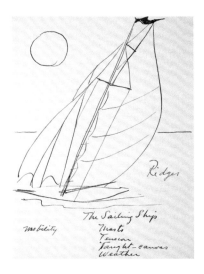

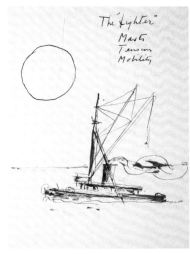

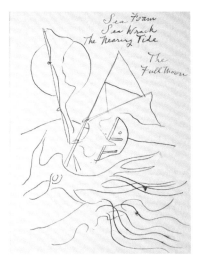

Shells

The Four Winds

The Spiral

The PinWheel

The Plan

man

Star

The Hand

The plan

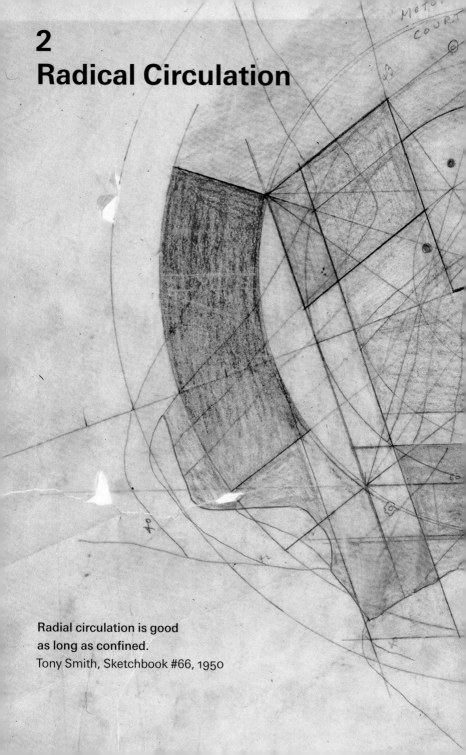

2
Radical Circulation

Radial circulation is good
as long as confined.
Tony Smith, Sketchbook #66, 1950

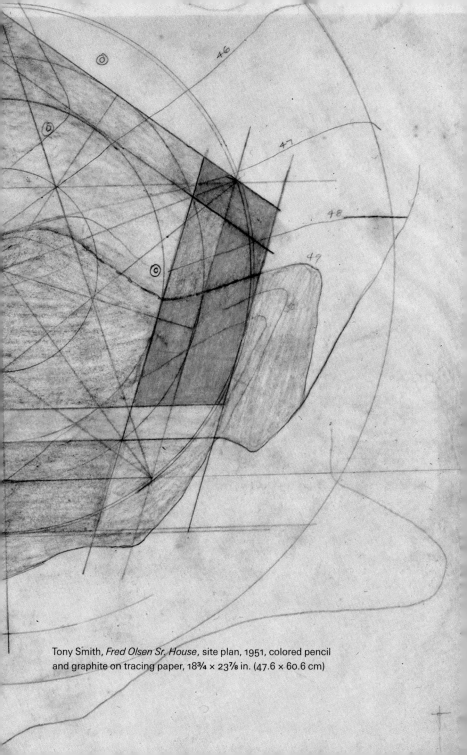

Tony Smith, *Fred Olsen Sr. House*, site plan, 1951, colored pencil and graphite on tracing paper, 18¾ × 23⅞ in. (47.6 × 60.6 cm)

Influenced by the writings of naturalist D'Arcy Wentworth Thompson in *On Growth and Form* (1917), a treatise on geometric form as found in nature, Tony Smith was inspired to employ Thompson's scientific analysis of the close packing of cells and their future behavior and structure.

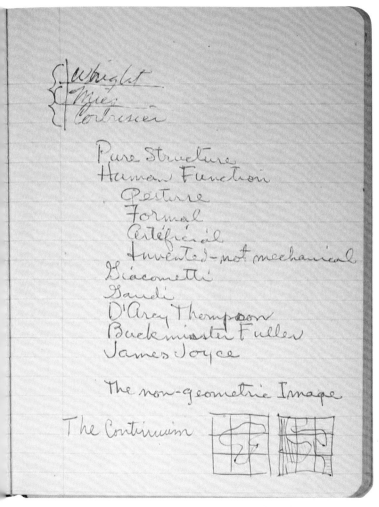

Tony Smith, Sketchbook #26, 1949–50, each page 9¾ × 7⅝ (24.8 × 19.4 cm)

Marta Kuzma

by the whole number of whorls, (or more strictly speaking) multiplied by the whole angle (θ) through which it has revolved: so that $r = a\theta$. And it is also plain that the radius meets the curve (or its tangent) at an angle which changes slowly but continuously, and which tends towards a right angle as the whorls increase in number and become more and more nearly circular.

But, in contrast to this, in the equiangular spiral of the *Nautilus* or the snail-shell or *Globigerina*, the whorls continually increase in breadth, and do so in a steady and unchanging ratio. Our definition is as follows: "If, instead of travelling with a *uniform* velocity, our point move along the radius vector with a velocity *increasing as its distance from the pole*, then the path described is

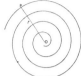

Fig. 349. The spiral of Archimedes.

called an equiangular spiral." Each whorl which the radius vector intersects will be broader than its predecessor in a definite ratio; the radius vector will increase in length in *geometrical* progression, as it sweeps through successive equal angles; and the equation to the spiral will be $r = a^\theta$. As the spiral of Archimedes, in our example of the coiled rope, might be looked upon as a coiled cylinder, so (but equally roughly) may the equiangular spiral, in the case of the shell, be pictured as a *cone* coiled upon itself; and it is the conical shape of the elephant's trunk or the chameleon's tail which makes them coil into a rough simulacrum of an equiangular spiral.

While the one spiral was known in ancient times, and was investigated if not discovered by Archimedes, the other was first

ellipses, would have been shot off in spiral orbits from the sun, the equiangular spiral being one case thereof.*

A singular instance of the same spiral is given by the route which certain insects follow towards a candle. Owing to the structure of their compound eyes, these insects do not look straight ahead but make for a light which they see abeam, at a certain angle. As they continually adjust their path to this constant angle, a spiral pathway brings them to their destination at last†.

In mechanical structures, *curvature* is essentially a mechanical phenomenon. It is found in flexible structures as the result of

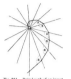

Fig. 351. Spiral path of an insect, as it draws towards a light. From Wigglesworth (after van Buddenbrook).

Fig. 352. Dynamical aspect of the equiangular spiral.

bending, or it may be introduced into the construction for the purpose of resisting such a bending-moment. But neither shell nor tooth nor claw are flexible structures; they have not been *bent* into their peculiar curvature, they have *grown* into it.

We may for a moment, however, regard the equiangular or logarithmic spiral of our shell from the dynamical point of view, by looking on *growth* itself as the force concerned. In the growing structure, let growth at any point P be resolved into a force F acting along the line joining P to a pole O, and a force T acting in a direction perpendicular to OP; and let the magnitude of these forces (or of these rates of growth) remain constant. It follows that

* *Principia*, I, 9; II, 15. On these "Cotes's spirals" see Tait and Steele, p. 147.
† Cf. W. Buddenbrock, *Sitzungsber. Heidelb. Akad.*, 1917; V. H. Wigglesworth, *Insect Physiology*, 1939, p. 167.

The Spiral of Archimedes, in D'Arcy Wentworth Thompson, *On Growth and Form*, ed. John Tyler Bonner (1917; Cambridge: Cambridge University Press, 1942), 753

Two diagrams (Spiral path of an insect and Dynamical aspect of the equiangular spiral), in D'Arcy Wentworth Thompson, *On Growth and Form*, ed. John Tyler Bonner (1917; Cambridge: Cambridge University Press, 1942), 756

In the growth of a shell, we can conceive no simpler law than this, namely, that it shall widen and lengthen in the same unvarying proportions: and this simplest of laws is that which nature tends to follow. The shell, like the creature within it, grows in size but not does change its shape; and the existence of this constant relativity of growth, or constant similarity of form, is of the essence, and may be made the basis of a definition, of the equiangular spiral.

D'Arcy Wentworth Thompson, "In Its Dynamical Aspect," in *On Growth and Form* (1917), rev. ed. (New York: Macmillan, 1942), 757

3
The Id Embedded
in the Wild:
The Productive
Imagination

Unpublished photograph from the Olsen family archives

Marta Kuzma

What is the meaning of id?
In relation to Wild?

WILD

Stanley Kowalski might have
been a pig - but he was ten-
der - and got the coloured
lights going.

Spiral-stair scene.

What about relation of
Orient to id?
Primitive to id? Clyf Still
Rousseau to id? Rothko
Nietzsche to id? Pollock
Dyonysus to id. Hofmann

Tony Smith, Sketchbook #26, 1949–50

Unpublished photograph from
the Olsen family archives

Tony Smith, Sketchbook #26,
1949–50

Marta Kuzma

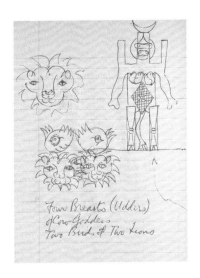

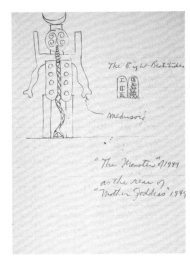

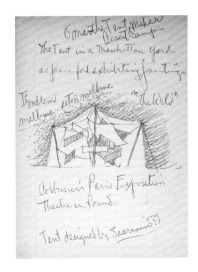

Unpublished photograph from
the Olsen family archives

The Olsen House

4
Mapping

Designed for Fred Olsen Sr. in 1951, the house is a self-contained, two-story building elevated on slender columns. Organized around an exterior court, it is constructed on a six-square grid with exposed steel beams. The house consists of three buildings that sit atop the highest point of the property, located within a stone quarry. The project radiates from this center of origin as a series of concentric circles that extend to the rim of the cliff, which marks the limit of the site. A five-pointed star oriented due north. Connecting the points of this star, there arrives the outline of a pentagram, which marks the dimensions and site location of the three building components: a studio that houses the client's art collection, the main living quarters, and the guest house. The main house and guest house are trapezoidal in plan, defined by the eastern and southern edges of the pentagram. A juxtaposition of solid forms and spatial voids. A convergence of existing topology with formally applied geometric patterning. [Paraphrased from John Keenen, "Architecture," in *Tony Smith: Architect, Painter, Sculptor* (New York: Museum of Modern Art, 1998), 45]

Tony Smith, Sketchbook #66, 1950, each page 8⅜ × 6⅞ (21.3 × 17.5 cm)

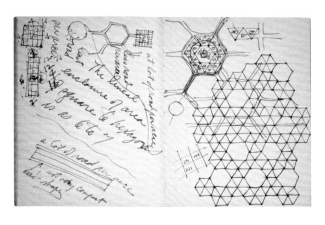

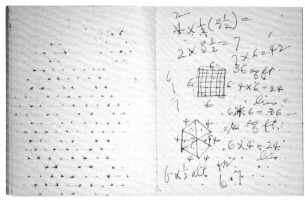

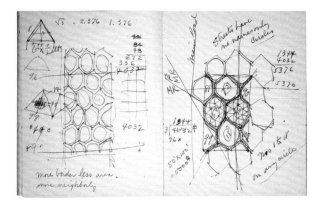

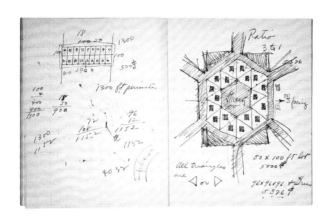

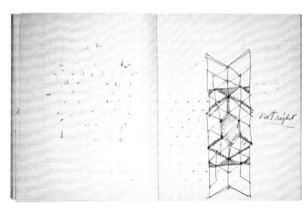

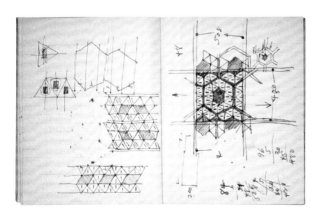

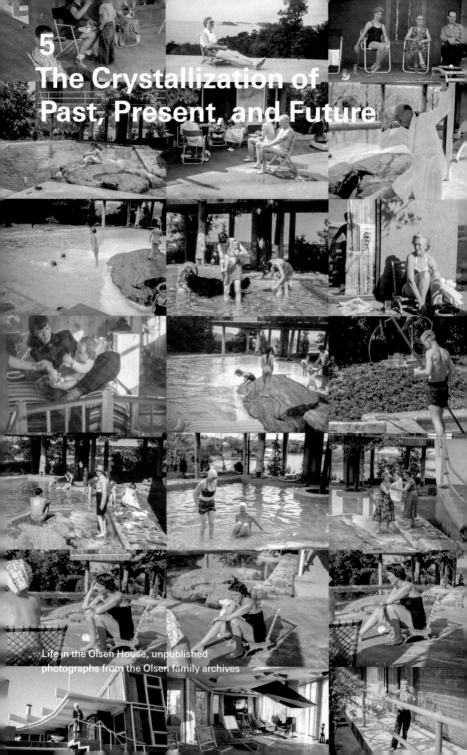

5
The Crystallization of Past, Present, and Future

Life in the Olsen House, unpublished
photographs from the Olsen family archives

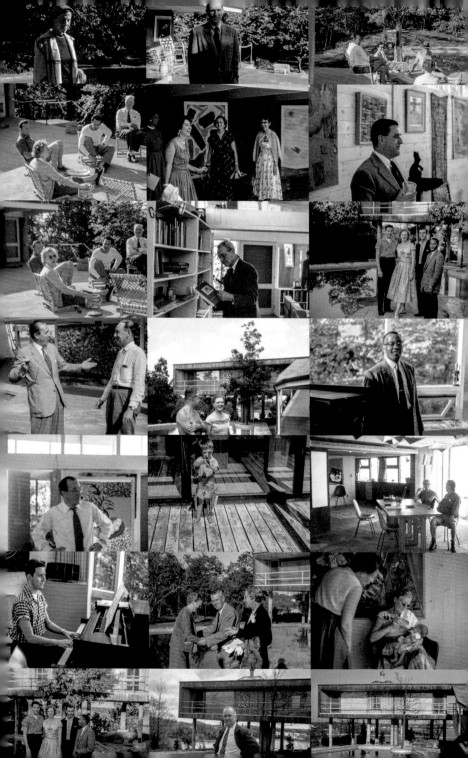

R. H. Quaytman

My Home:
A Pentagon

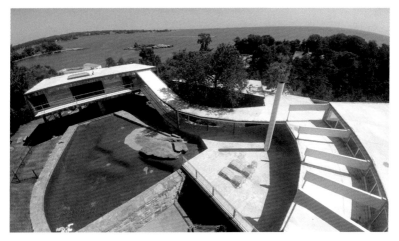

Fred Olsen Sr. House, 1951–53, Guilford, CT, 2019

It took me a few years to realize that the orientation of my home follows the path of the sun. It wakes me up every new day with piercing hot rays rising—on the left side of a large rectangular window perpendicular to my rectangular bed. Over the course of the year, it slowly moves to the right in winter and back in the summer. In the evening, the sun begins to set northwest, shining through the house's biggest window located in the main shape. Pavilion? Room? Gallery. The panes of these windows are divided according to the golden mean into smaller sections of rect-angles and their reciprocal squares. Waking up with the rising sun, and ending the day with it sitting at the table next to an open kitchen, where I write this now—in the cycle of days and nights, seasons and decades,

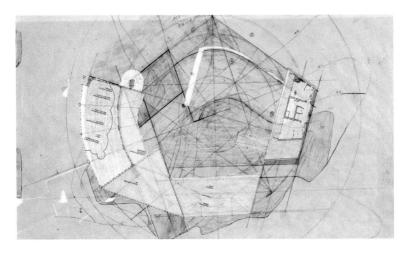

Fred Olsen Sr. House plan with contemporary building plans
superimposed on Tony Smith's original drawing

in this house—feels very beautiful to me. It gives the feeling of slowly
rotating with the earth in the cosmos, a steady revolving movement
that rises to meet the sun and sets to meet the evening.

Curving in accordance with the laws of geometric growth around
an outcrop of ancient pink granite, rising out of a saltwater pool just
barely. The property's pool and three surrounding structures, each with
its own function, are linked by a sprawling cement slab. I call them the
Tree House (guest house), the Cave (my bedroom), and the Tent (the
kitchen/living area). The cement patio connecting them creates an
open living plan, moving between inside and out. The site sits atop one
of the few high outcrops on Connecticut's coastline. Looking into the
distance, as far as the eye can see, is always a good feeling. (Sigh) I
guess I'm in love, Tony Smith. Your geometry is generative and gives a
feeling. It is beautiful to live in. I think your pentagonal dream fulfills a
wish for a house that is fit perfectly for one. Because it is perfect for one
artist, who except for the occasional visit from friends in the Tree House,
lives alone, as they have chosen.

When Tony Smith first visited the site in 1949, it was the rubble-
strewn remains of a quarry that had closed down years before. The

My Home: A Pentagon 143

Slide photograph, original site for house

rocky landscape must have appeared like landing on the moon, stripped as it was of vegetation. The unique granite found in this area was formed from crystallized magma from erupting volcanoes millions of years ago. Its pink hue comes from a concentration of iron in the potassium feldspar. Many of Manhattan's civic landmarks were built with this stone, including the Statue of Liberty, Grand Central Terminal, and the George Washington Bridge. Smith chose the highest point on the roughly three-acre lot to situate the center of a pentagon on which the entire logic of the architecture would evolve.

He must have been attracted to the geometry of the pentagon, the fifth Platonic solid, for the long, illustrious, and somewhat magical

Unpublished photograph from the Olsen family archives

R. H. Quaytman

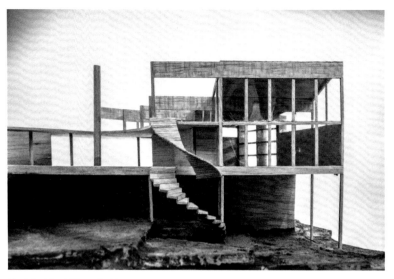

Model of Fred Olsen Sr. House, 1951–53

history it unravels. The pentagon served as the penultimate shape according to Pythagoras. Its five-pointed internal star, the pentagram, is associated with the occult and witchcraft. It is also known to ward off evil. The five Platonic solids symbolize the five elements, but Plato gave the dodecahedron—a twelve-sided regular polyhedron made of twelve pentagons—the element that follows the other four, representing the cosmos. It is connected mathematically to the golden ratio. As the story goes, Smith dreamed of a pentagonal house, which appeared "like a Goddess, complete."[1] He affixed the center of the house on the very rock that juts out of the gunite-lined, saltwater swimming pool—unique in its own right, deflecting from the rectangular or oval shape that dominated other modernist pools at the time. Smith built into the existing rock and landscape to form a natural watering and swimming hole, with jutting rocks as points for basking in the sun. It reminds one of the pools constructed for penguins or polar bears in zoos. In the summer, the social center of the house pivots outside to the deck, which acts as a kind of centrifugal point around which three segments of a downward spiral emerge.

Author's photograph

Purchasing the House

I could not say that Guilford, Connecticut, is an interesting place—were it not for its saltwater marshes, swaths of publicly owned woodlands, and these pink granite quarries that pierce the landscape around 72 Old Quarry Road. I will never forget seeing it for the first time, in 1999, with my then-husband and lifelong friend, Jeff Preiss—we were both stunned. The architecture Smith had dreamed of and built was unlike any other place in 1953. Hexagons, maybe—but pentagons? All that was left now, however, had an eerie feeling of abandonment. By the time we first saw it, the property was quite, but not entirely, run down, the pool falling apart, with dilapidated and broken artworks haphazardly scattered or nailed to different parts of the house and landscape. A rusting cistern (there is no well for freshwater, nor municipal waterlines on the property) looked like an old tanker that had washed up on a beach. Recovering from our baffled amazement, we realized over the next week how wonderful the place must have been and still could be, with a little restoration. A protracted battle ensued with another prospective buyer, a local liquor distributor, and his wife (who, by the way, had an architecture degree). Their plan was to tear down the house and construct a McMansion meant to be seen, triumphantly, from a great distance.

Thankfully, we were able to purchase the property in 1999, thanks to the efforts of Marjorie Olsen, second wife of Fred Olsen Jr., and the late Terence Riley, chief curator of architecture and design at the Museum of Modern Art. We won by just one vote in the property owners' association. We were able to hire Keenen/Riley, experts in Tony Smith's architecture, who at the same moment were organizing a large exhibition of Smith's work at MoMA, to restore the property.

The Olsens

Dr. Fred Olsen Sr. and his wife, Florence Quittenton, were the original inhabitants of the house. Dr. Olsen's development of smokeless gunpowder, widely used during World War II, allowed him to amass a sizable fortune. I wonder if Smith got the title for his 1967 sculpture *Smoke* partially from thinking through the source of this client's wealth.

During their time here, the Olsens made a number of alterations to the house, which diverged from the logic of Smith's already eccentric plan and created a kind of chaos of awkwardly attached buildings. The Tent and the Cave were sutured by an enclosed addition three years after Smith's original design had been completed. This alteration made one long, crescent-shaped room, which contained a motley assortment of furnishings that seemed out of joint with the twentieth century. Smith's original design was almost entirely obscured. Another wing was added on the ground level with wall-to-wall metal shelving designed to accommodate the Olsens' growing collection of cultural artifacts. The house cannot be seen until one rounds the bend of a curving driveway toward an open carport tucked under the slab on which the three buildings are linked. Originally, the main pavilion rose dramatically on tree trunks

Unpublished photograph from the Olsen family archives

supporting a giant glass window above the driveway. The Olsens' addition all but cut down the architectural point of the tree trunks and their reason for being, to support this large room as a self-enclosed shape. These changes were a grave disappointment to Smith. The integrity of his original plan for the house had, after all, gone up in smoke by the time another Fred—the son of Fred Olsen Jr. and grandson of Fred Olsen Sr.—showed us the property. I remember he confessed that the cook had stayed on for quite some time after both Olsens were deceased, living downstairs in a tiny bedroom with a stovetop and refrigerator for years. When we moved into the house, our first order of business was to remove the Olsens' many additions, restoring the original indoor/outdoor flow of the architecture. Our major change to Smith's design was to move the kitchen and living area out of the Cave and into the Tent, which had first served as a gallery.

It came as a surprise, in researching Smith again for this essay, that he had completed the smaller, "next-door" house first, in 1951, for Fred Olsen Jr. and his first wife, Betty. It is referred to as the Junior Olsen House and is beautifully situated next to the water, directly below my house, as I can see clearly from the Tree House. From what I can glean in the correspondence, it was Betty who perhaps first made

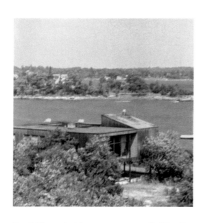

Fred Olsen Jr. House, 1951–52, Guilford, CT, unpublished photograph from the Olsen family archives

contact with Smith, but I have no other information about that friendship. Betty was an artist and wanted Smith to design a house with a studio for her to work in. Perhaps they met at the Art Students League in New York City. How Fred Olsen Sr. came to know and collect Barnett Newman, Isamu Noguchi, Jackson Pollock, and Mark Rothko, I cannot quite figure out. Was it Betty Olsen? The main point is that Tony Smith was close friends with all of them. I know that Rothko once visited the

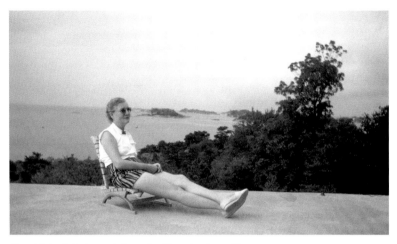

Unpublished photograph from the Olsen family archives

house and that Noguchi spent time here. There exists a slide of Mark Rothko sitting in the kitchen, and a few of Noguchi sitting with his legs hanging over the edge of the patio before architecture codes became stricter and legally required railings. I received two large boxes of slides from Elizabeth Kyberg, the senior Olsens' second child, who lived much of her life in and around the old quarry. I remember reading somewhere that the original developer of the quarry derisively called the house "the factory," and had warned Fred Olsen Sr. that "he would quickly tire of it and sell it to some Greenwich Village hippy." In a sense, this did come to pass (I proudly claim the characterization), although the Olsens never tired of the house, living in it to the end of their days. I was once told that Fred Olsen Sr. used to terrify his nurse by speeding in his wheelchair to the fenceless edge of the patio, which juts out over a cliff, as if to fling himself to his death.

Tent

Ascending the spiral staircase from the carport area, one enters the Tent, comprising three trapezoidal shapes. It is important to note that

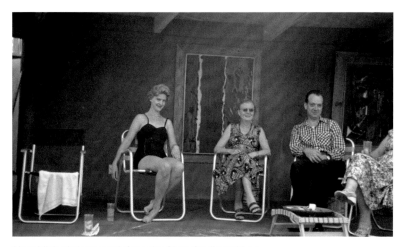

Unpublished photograph from the Olsen family archives

Smith composed the architecture to avoid displaying the stunning view of Long Island Sound—in fact, he actively and counterintuitively positioned the structures of the house away from the view, with the Tent's largest windows facing the woods rather than the ocean. Here is the heart of the house where the Olsens hosted numerous parties, concerts, and exhibitions. The light coming through the west-facing windows is blinding and bakes the whole room in summer but beautifully warms the space in the winter. The Tent also offers its exterior, east-facing wall as a place to hang painting outdoors under the wide wooden awnings, which provide shade and protection from the elements. In the slides, one can see how they hung modern art outside on the exterior around the patio. Smith had urged Jackson Pollock to make a work for the house (I'm speculating) and helped him begin painting *Blue Poles* (1952) to be hung in what is now the kitchen/dining area below the windows facing due west—on those walls of white-stained wood slats that Smith favored.

Pollock, Barnett Newman, and Tony Smith were together one evening in Jackson's studio. Jackson showed Barney and Tony the way he was "flipping" paint onto the canvas. Barney and Tony each tried out a flip of their own. That was the total of the joint effort, the total of

R. H. Quaytman

their contribution to the very beginning of the underpainting of a canvas that, ultimately, layers later, became "Blue Poles."[2]

The Olsens soon sold their *Blue Poles* for, reportedly, $6,000.[3] There was also a Henry Moore sculpture on the patio as well as Coptic artifacts. Their collecting later shifted to anthropological pursuits focused on pre-Hispanic Arawak peoples.

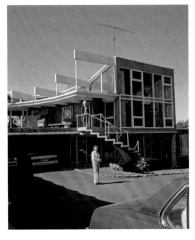

Unpublished photograph
from the Olsen family archives

The Cave

Originally intended as a summer home, Smith's cave-like dwelling squeezes domestic life into a space the width of a train car or camper. The Cave mirrors the dimensions and design of the Tree House, which

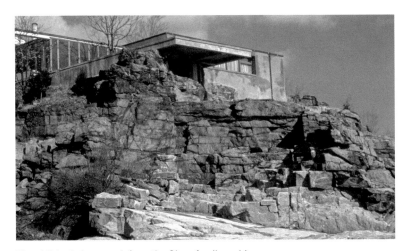

Unpublished photograph from the Olsen family archives

rises behind it on ten sturdy tree trunks. Perhaps this construction recalls the idea of living separately from the main house, as Smith experienced in his childhood. Born in 1912, Smith was quarantined for tuberculosis at age four, living with a nurse in a small, prefabricated cottage behind the family home in South Orange, New Jersey.[4] The Cave, of course, became quickly inadequate for the Olsens' needs once they moved here full-time. The way Smith separates everyday family needs, like bedrooms, bathrooms, and kitchens, reminds me of growing up in the Greenwich Village and SoHo artist lofts of the 1960s and '70s. Women and children were often squished toward the back of these industrial spaces, behind the light-filled bigger part in the front of the loft where the mostly male artists would spend the day having ideas and making art. Now the Cave is my private salon along with my cat Anger.

The Patio, Pool, and Pole

Another unusual detail is how the outdoor patio connects the three buildings and the pool. The patio has a spidery but strong shape that is

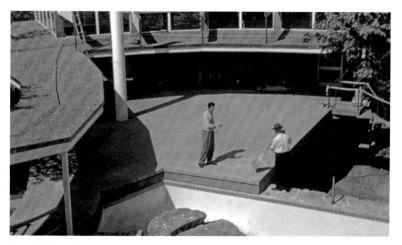

Unpublished photograph from the Olsen family archives

more like a membrane than a floor, having to stretch dramatically up an aggressively steep incline to the Tree House. The simple materials the Tree House is made with are all locally sourced lumber, steel, and plumbing supplies. The railings seem like plumbing pipes tied together. The other notable detail is what looks like a giant cigarette or huge smoke stack (still functioning) for the boiler right in the middle of the patio. I noticed that Florence is never seen without one in all of the slides. And to be honest, I never say no to a cigarette. The steep and sturdy steel ramp attaching the Tree House to the overall structure is also, from an engineering standpoint, what keeps the Tree House standing in high winds from increasingly frequent storms and hurricanes coming in off the Sound. Otherwise, those ten tree trunks would not be adequate. In the summer, everyone is drawn to the middle of the patio, as if by some invisible gravity, to sit around, talk, swim, eat, and drink. There is always a breeze that keeps one cool, and the mosquitoes and flying insects do not seem to bother people up here as much as all the other houses in the trees.

The high outcrop of pink granite on which the house is sited must have been a precious location for the Menunkatuck and Totoket peoples because of its height, providing long vantages across Long Island Sound, which is not visible from the lower coastline. But up here on clear days, Long Island's jagged silhouette defines the horizon. Sometimes I feel as if I am standing in a vast bowl, the edge of which is a hundred-eighty-degree horizon at eye level.

Geometry

Excited about owning and restoring this house, I read about the strong influence of D'Arcy Wentworth Thompson and Jay Hambidge on Smith. Thompson's *On Growth and Form*, originally published in 1917, explains how all life is inseparable, and the fecund biological diversity we find in thriving environments is how life evolves and develops toward complexity. Diversity springs from and grows into what it is because it is inseparable from the pressure of what surrounds it. It is easy to say that form is mutual and nothing is separate, but this book made me feel it. Language, with its dependence on nouns, distorts this biological reality.

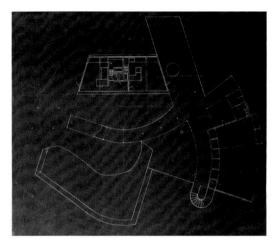

Tony Smith, *Fred Olsen Sr. House*, 1951, blackprint,
14⅛ × 16¾ in. (35.9 × 42.5 cm)

But it was Hambidge's *Elements of Dynamic Symmetry* (1919–20) that
changed the structure of my own work. In 2001, I began to implement
his ideas related to dynamic symmetry when deciding on panel dimen-
sions for my paintings. Ever since, I have made my panels according
to the golden ratio of the square to the rectangle. This enabled me
to place different-looking paintings together in a way that generates
hieroglyphic legibility via their geometric dimensional and nesting rela-
5tionships. Hambidge taught me about mathematical concepts, like
the Fibonacci series and the difference between rational and irrational
numbers. It led to an ongoing interest in geometry—how drawing a
pentagon, for example, is a revelation even if done incorrectly. During
that time, I was also influenced by the Polish sculptor Katarzyna Kobro
(1898–1951) and the American architect Anne Tyng (1920–2011). I know
these emotions around Φ (phi) and the golden section are often per-
ceived as a little common, or dime-store. But I cannot help it. I do have
emotions about geometry. I do believe in what it advises, and I love
living in the centrifugal pull of a pentagon.

 To me, the house is a sculpture. It is a sculpture about an artist
and how they could live in a cave making and showing their art in a
tent and possibly inviting other artists to the tree house to also work

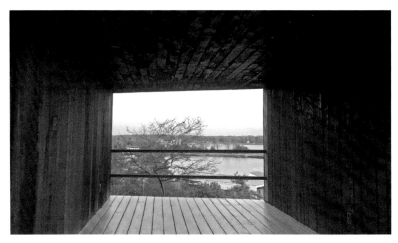

View of Long Island Sound from the house

here. I should just batten down the hatches and bring back the house following Smith's original dream, and move the kitchen, dining room, bedroom, and bathroom back into the Cave and make the Tent a studio/gallery again, with walls not painted but stained white. Maybe I could do that. Maybe I will. If you conceive it to be a studio/house for one artist, it does feel like a dream.

1 From John Keenen's interview with Hans Noë, a friend and colleague of Smith's, April 13, 1993. See Keenen, "Architecture," in *Tony Smith: Architect, Painter, Sculptor*, exh. cat. (New York: Museum of Modern Art, 1998), 37.

2 Ben Heller, letter to the editor, January 25, 1990, *New York Times*, February 9, 1990, A30.

3 Israel Shenker, "A Pollock Sold for $2-Million, Record for American Painting," *New York Times*, September 22, 1973, 65: "The sale was confirmed yesterday by Ben Heller, the New York businessman and art collector who was a close friend of Pollock in the artist's last years, and who has owned the painting since about 1956. He bought it then for $32,000 from a collector who had paid $6,000 about three years earlier."

4 See Robert Storr, "A Man of Parts," in *Tony Smith: Architect, Painter, Sculptor*, exh. cat. (New York: Museum of Modern Art, 1998), 12–14.

Life in the Olsen House, photographs courtesy of R. H. Quaytman

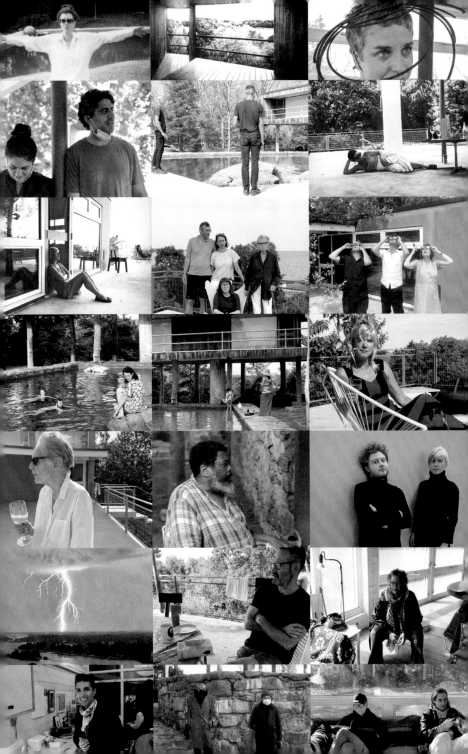

6
The Plan in Motion

Olsen House under construction, ca. 1951

Olsen House under construction, ca. 1951

Olsen House under construction, ca. 1951

The Olsen House

To bring to architecture from the level of prostitution to that of the spirit that must inform America's coming years (we) are going to work as artists not business men—giving not selling or trading. With every regard for those who would ask us to design buildings for them, our total responsibility to our "client," nation, time, god forbids that our completed plan to be built according to any intention other than our own.
Tony Smith, "The Pattern of Organic Life in America," 1943–45, unpublished manuscript

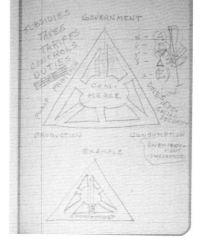

Tony Smith, Sketchbook #26, 1949–50

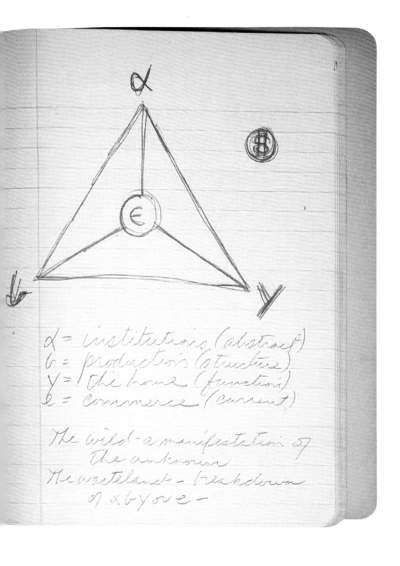

α = institutions (abstract)
b = production (structure)
y = the home (function)
e = commerce (current)

The wild - a manifestation of
 the unknown
The wasteland - breakdown
 of α b y o e -

7
The Economics of a Building, How to Estimate Construction Costs, Control Finances, and Project Management

1938

Tony Smith begins as an apprentice to Frank Lloyd Wright. His first assignment is as a laborer on the construction site of the Suntop Homes in Ardmore, Pennsylvania, which provides him with a pragmatic approach to architecture.

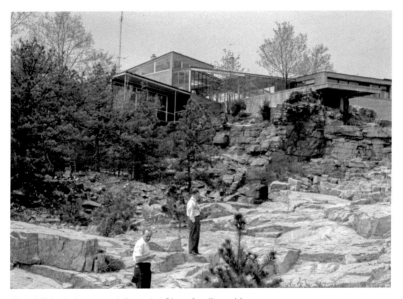

Unpublished photograph from the Olsen family archives

Marta Kuzma

Architect
Engineer
Excavation
Cellar Drain
Foundation
Cementing
Columns and Piers
Sewer and Water
Drains and Dry Wells
Rough Grading
Finish Grading
Walks and Driveways
Brick work
Brick Steps
Finished Fireplaces
Lathing and Plastering
Grounds and Plaster Beads
Painting
Wallpaper
Roofing
Plumbing
Heating
Electric Wiring
Electric Fixtures
Gas Service
Gas Range
Frame
Roof Boarding
Roofing
Wall Boarding
Wall Siding
Under floors
Flashing

Gutters
Conductors
Outside Finish
Piazza Balustrade
Piazza Floors and Sheathing
Roof, Windows and Blinds
Inside Finish
Upper Floors
Laying Floors
Linoleum
Sheathing Paper
Nails, etc.
Hardware
Carpenter Labor
Door and Window Screens
Weather Strips
Shades
Glazing
Tile Floors
Bath Room Fixtures
Temporary Heat
Cellar Work
Fire Stopping
Window Cleaning
Insurance
Trucking
Expense

Overhead
Profit.

Tony Smith, Olsen House specs

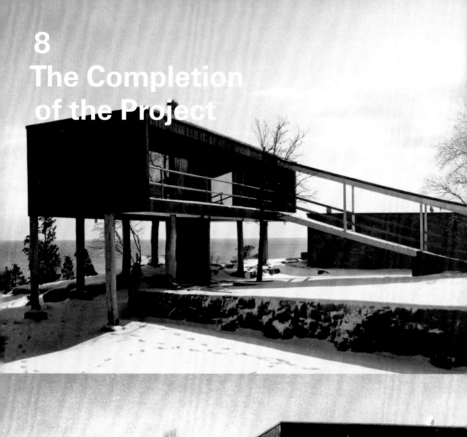

8
The Completion
of the Project

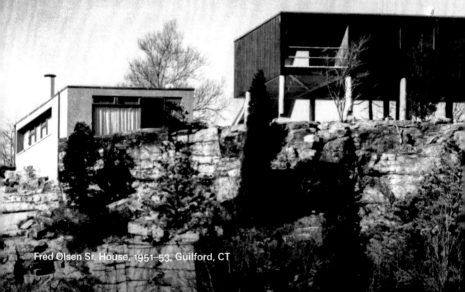

Fred Olsen Sr. House, 1951–53, Guilford, CT

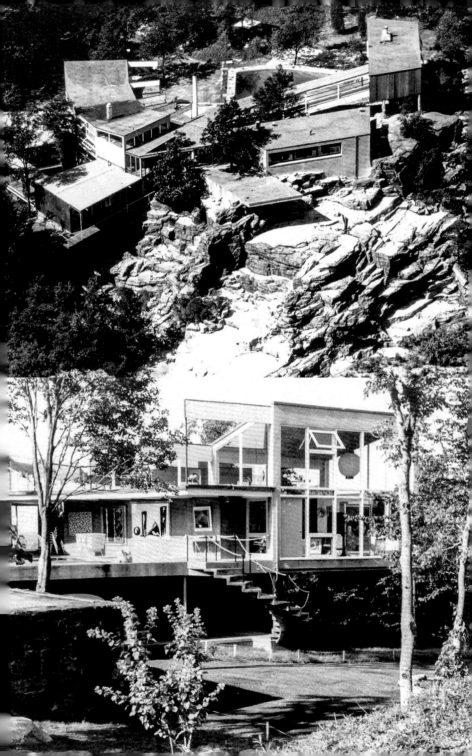

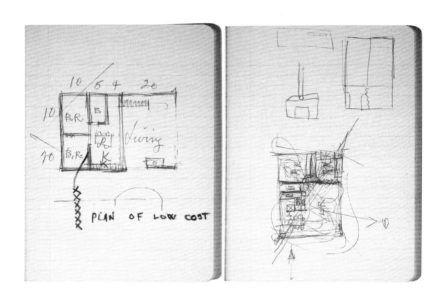

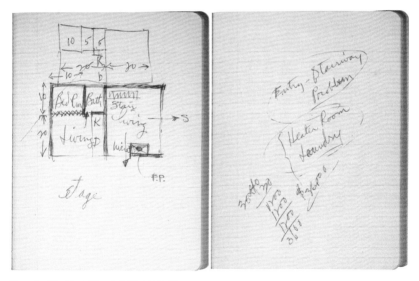

Tony Smith, Sketchbook #26, 1949–50

Marta Kuzma

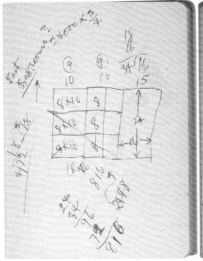

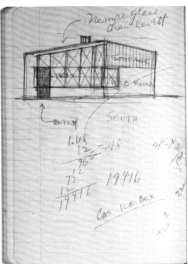

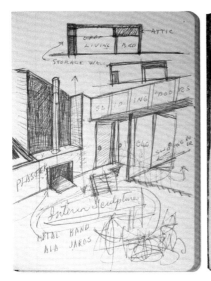

9
The Post-Construction Conversation

Heidelberg,
Kaiserstrasse, 3,
bei Biallowons.
Wed., Aug. 19, '53.

Dear Fred and Betty:-

I hope all has been going well with you. Jane is so much in the same condition as Betty was bragging about that she is going to skip the coming opera season until April. She had intended to go to Karlsruhe about now. As it is we don't know exactly where we shall go; but it will be in Germany because she wants to continue in that style for a couple more years. The building program in Germany was about finished when I got here, so I haven't been doing anything, which in some ways has been just as well because I still get tired very easily. I may be able to get a teaching job, or do something in relation to the State Dept. building program if it has not been economized out of existence. In regard to the latter, and while I would like some kind of job, I must say there seemed to be an awful lot of scrip around. Although of course I have no way of knowing what it has brought to the U. S. except an appreciation of our resources. Most Americans I have seen appear to be a rather vague, and possibly sullen, lot conscientiously enjoying their prosperity. Of course existing as we do halfway between the German economy and 'little America', as it is called I may not have a very distinct picture.

The old part of Heidelberg, the castle, the churches, old bridge, and general situation with the river flowing between green hills, is soft and beautiful; the rest is perhaps like the less busy parts of Brooklyn or some other American city in which I have not lived. The best things I have seen have been the outdoor productions of Shakspear in the court of the castle, the lighting of the latter on feast days with some kind of red flares, the circus, and the fireworks displayed from the bridge over the Neckar. Since Jane's salary amounts to about thirty dollars a week net most of our traveling has been on the street cars, but occasionally someone has taken us for rides and we have seen the Grunewald in Colmar. That of course is worth coming to Europe to see.

Tony Smith letter to Fred Jr. and Betty Olsen, August 19, 1953

Marta Kuzma

There is almost no modern building anywhere near here. But I have
seen the siedlung which Corbu, Mies, Gropius and others did in the
twenties in Stuttgart. The larger of Corbu's two buildings there was
a big influence in your own house, although the degree to which it
was is not very evident from the enclosed snapshot. The whole layout
with a broad lawn in front of it and looking over the valley town to
the hills beyond is the best use of a town site I have ever seen. I
have also seen the apartments for German employees of the state dept.
at Bad Godesberg, done by Skidmore and some German architects, and they
are very fine if not top notch. Most work done for the Americans is an
utter bastardization of American living standards with a high gable
planted on top. The buildings are usually disposed in relation to one
another as are garden apartments, which is altogether out of character
with the medieval crowding against one another of German buildings,
and along with being too high for the gables, they are an utter mess.
The State Dept. attitude of uncompromizing modernism is not only far
less insulting to everyone, but in everyway more successful. For all
the talk of the superiority of American motor cars, and other such
things, these buildings, either built or proposed by the State Dept.,
are the best evidence of clear thinking on the part of Americans that
can be seen materially. About other things I am not in a position to
speak. It is strange that the Nazis so obliterated evidence of the
Bauhaus that most Germans don't even know that these fine buildings
are largely the result of German thought in the twenties. Amerika Haus
posters and displays in the Bauhaus style of typography and layout are
the only other things one sees of this kind and they are thought of by
the Germans as being the American way. Of other things to be seen I
have been startled by Willy Messerschmidt's three-wheeled, two-seater
(tandem fashion), aluminum and plastic cross between a scooter and
automobile, and all I can say is that it is a weird bug to be prepared
for which one would have to be familiar with other continental modes
of travel. Any street here is at almost any time a most complete dis-
play of the entire history of the wheel. Babies are balanced on bicycles
and motor-cycles in ways which are associated in our minds only with
the most advanced vaudville. I expect to see one any day astride the
cowling of one of Messerschmidt's cars(especially since inside there is
room only for the mother and father). The cowl itself is just the size
and height of a pony's back, and with the universal vogue of plaid
shirts here, it could become the closest real life approach to the equal-
ubiquitous Western Film.

As you might have expected I have not learned any German (somewhat to her dismay Jane has to do all the ordering, enquiring, etc.) and since I think Americans must suspect that I am a Bolshevik, I am alone a great deal. Besides some books (which I can get at the Amerika Haus library) I read the Paris edition of the Herald, and the international editions of Time and Life, do a certain amount of thinking, and some work. I have designed a new church with solid walls and an all glass roof (gable) inspired by that quarry building you pass on route 80. The intention would be to create a white, spirituallinterior in which abstract paintings would be used. It is not very exciting (or very modern) to look at, but I believe the inside could evoke a great deal of feeling that has not so far been as clearly expressed. I sent Pollock some sketches for a tent I designed for his three big pictures at the time he did them. I designed a new small house which I have sent Strelsa because it made me think of her. I have done one nice row of houses with courts, and have fooled around with some other row and apartment houses. After thinking about it a lot I still think the house I showed you (which is enclosed) is the best for prefabrication I have seen. On the one hand it is a real building, not just a large gadget dropped on the landscape, nor is it an imitation of a traditional house abortively produced by industry. Further it does not require a million dollar plant to make the first one; it could be produced in terms of any stage of industrialization. I think there would be a large market for the house just as it is, and then it could be the first unit of a group of buildings as I showed you; the living-dining area would eventually become the parent's bedroom, with the kitchen becoming their bath. The house could be built not only by builders, but could be sold in packages to those who would like to do their own work, and buy the parts as they needed them. This would appeal not only to a certain type who would recognize it as their only chance of getting a house, but also to those who would like to have a second house for weekend and vacation use. I realize that you may not consider me very practical, but I have noticed that even in business some things have come from what may have appeared as disasters. I believe that this house is architecture. I believe that any real developement in prefabrication is going to come not alone from the building business, nor from established industry, but in large part from architects who have a greater intensity and a broader vision than seems to have been involed so far in speculation homes or in any

of the other so far more specialized products of industry. By saying this I do not mean to even suggest that I expect people to live any-thing like a consciously aesthetic life. I just feel that ordinary life itself has a dignity which has not yet been realized in this case in terms of existing means. It is because I feel that you understand these things and have the means of doing something about them that I am ask-ing you to think over the idea of making one of these houses. I am sure that the best way of approaching it would be to build one in the ordi-nary way, either for someone who could use it (possibly Elizabeth and Hank), or just to study and sell. If all went well, as I am certain it would, about ten could be prepared in a small shop (as the parts of Jap-anese houses are produced), with attention to how the various parts could be better produced by industrial methods. At this stage, probably a large number of items could already be done on a jobbing basis. Final-ly, the whole thing could be mass produced. When I say that I feel this could be the model T of the housing industry I am speaking out of con-viction, and a genuine ambition, not merely my day in and day out vanity. Since I have not only not the way of raising capital, but even the pos-sibility of having this idea move smoothly into a mass production system even with the capital, someone else must inevitably be involved. Would you personally be interested? In considering this in relation to myself please realize that during the time I have known you I have been in the worst straits and the most handicapped of any period of my life; I don't ask you to dismiss this, butto balance it against the conceptual power of which you can also see the evidense, and I hope enjoy. I also bring this up with you because, if you recall, when I first showed it to you I said that I had gotten the idea of it from having done your own house. If I had not done your house I would never have had this idea. The idea of it further evolving into a multi-unit proposition I got later from your Father's house. It evolved from those houses, and I would like to see it further evolve. It is also a house that would have a real sense of life of its own. It is not just some 'poor man's version' of some-thing else, as is so often the case of the builder's house. Anyway!

<div align="right">Love</div>

Stuttgart,
Danzigerstr., 8a,
Sonnenberg,
bei Pattee,
Deutschland.

Dear Fred and Betty:-

Congratulations! Had a letter from Tony Louvis who said that the
mother and son were doing well, and that there were some unstretched
canvases hanging about the studio. Time seems to pass faster in some
things than it does in others. I had no idea it would be so soon. You
must be very happy.

The address above is not an indication of a job or a new residence;
it is just an address for mail. Jane expects to get some money from home,
and since neither of us are working, and since she will not be able to
travel very much after a couple of months, and since we have never gone
anywhere together, we are going to take a trip for about six weeks. We
are going to travel third class which is cheaper than busses, and buy a
certain amount of food as we go rather than eat always in restaurants.
We are not going to try to see a lot of architecture, painting, or sculp-
ture, but just take a quick passage through the towns and landscape, with
the exception of having a good look at Corbu's great apartment building
in Marseille. We are going down to Italy by way of the Brenner Pass, and
probably going as far as Pompeii. Then we shall go along the coast to
see some of the towns in Provence, and on to Barcelona. From there we
shall take the boat to Mallorca, from there to Alicante, Madrid, probably
Valladolid, and starting at Bayonne back across France. We expect to spend
about two weeks each in Italy, France and Spain, if all goes well. We
heard from Donnie that Tennessee was in Rome (although he intended to
spend the summer on the island of Porus near Athens) so we shall see him
if he is there. The whole thing may seem rather wild but we feel it may
be our only chance for a long time.

Since in sending you the sketch of the house for production, I felt
that I had taken some action on it, it started a new series of develope-
ments, on it and some other things. If you recall, when I first showed it
to you, the columns were twelve feet apart from side to side, with cable
cross braces in the walls under the windows and the slight overhang canti-
levered. As you may have noticed when you were here most German houses have

Tony Smith letter to Fred Jr. and Betty Olsen, undated (ca. 1953)

a shutter-awning combination which works somewhat like a roll-top desk cover. This serves a variety of purposes; it can effectively lock up the house in the absence of the owners; it keeps in a certain amount of heat, and is a protection from winds in the winter; it keeps the sun off while allowing ventilation in summer; and it can be used to insure absolute privacy if it is desired, without being as great a fire risk as a double row of curtains. Seeing this reminded me that many years ago I had seen what amounted to the same idea in the form of outside aluminum venetian blinds. The latter scheme is much more flexible than the German way, and it does not project beyond the building line as does the German one when it is used as an awning. Now, in the version I sent you, I had moved the columns out to the sixteen foot line; this was partly because while in the first version I had thought of the entire house as a single unit, I was now thinking of it both as a unit complete in itself and also as one which would simply be the first in a group, the others of which would be added later as the needs and the means increased. By putting the columns on sixteen foot centers both ways, a greater order could be acheived in tying all the units together in a single system. Once I sent it however I realized that by making the module 5'4" instead of 4'0" crosswise, while retaining the same divisions lenghhwise, I could get a much larger floor area under the same roof. This would allow not only more living space, but a greater amount of cube, and a greater amount of radiant surface for the same amount of window area. It would also make it possible to go back to the cross-bracing between the columns, which would make it possible to use lighter columns as in the first scheme. (Since the steel would run only crosswise the problem of making connections in light columns doesn't arise as it did in your house. Then by going back to double-hung windows, which work out very well in aluminum, and using the outside venetian blinds the problem of the overhand is overcome. The latter is important because in a mass production house orientation cannot be considered a matter of choice; it must be suited to a variety of orientations. It may seem that the latter scheme might have occurred to anyoneelse at once, but I have to be clear about the architectural concept before I can proceed to the more specific realms of structure and function. The house which is enclosed incorporates these changes, and the further addition of the cover to the stairway which is corrugated aluminum over the horizontal part (and curved as shown for drainage), and

wire-glass (with gutter but no downspout) over the steps. Now since the
floor area is the full width of the building, and since the cross-bracing
would increases the stability of the columns, I have raised the entire
house the the level where there would be six feet eight inches head room
under, to provide a shelter for the car, an outdoor sitting space in the
shade, play space for children, and work space for adults. This would
also increase the vista from the house, and on ground level. It is still
necessary to take a twelve foot run and jump to get from the under part
of the house to the covered stair, but I have not found any acceptable
architectural solution; it is not very far anyway, and most people ac-
cept going much further; I like it anycontributing to art and fresh air.

The above is the state in which you have the thing herewith. But
once I put it in the air, I realized it would be better to put the heat-
er, and a small storage space (both together occupying 5'4" x 12'0" on
the units) under the house, and by changing the position of the refriger-
ator and so reducing the size of the kitchen it would be possible to
extend the small bedroom to the extent that with a modernfold door to
separate them it would become two sleeping spaces, 8' x 10' each which
is plenty. This latter scheme has made it necessary to back to the 3'6"
hall so as to provide adequate storage space, but it allows a nice lit-
tle toko-like space opposite the entry. This latest scheme has the one
disadvantage that there is storage space only on one side of the double
bedroom, but it did not seem worth taking two feet away from the parent's
room just to gain it. On the other hand it makes the whole plan much more
flexible, and almost a three bed room house. I do not claim that this is
a great feat in the given amount of floor space; it can be done easily
on a square plan (which doesn't have so much hall space). I am saying
that this way of building a house is very well suited to mass production
on the one hand, and I am making the prediction that people will soon
tire of the gable type house with so-called free spaces andmsquarer
plans, and that they will come to prefer houses with more classically
defined spaces and greater articulation. You feel freeer if you can take
a little walk in your house, and if you can feel the freedom of spaces
around the one you are in, and not just the gothic freedom of the one
you are in.

It may seem presumptious for me to go into so much detail when I
have no idea about your interest, but in any case it gives me the oppor-
tunity to write it down, and if you should be interested, it helps to
makesit more concrete. I shall send the latest when I can.

I am certainly happy that the baby arrived safely. T.

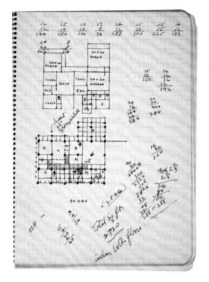

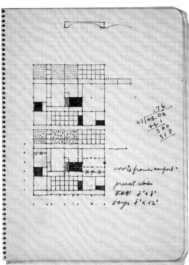

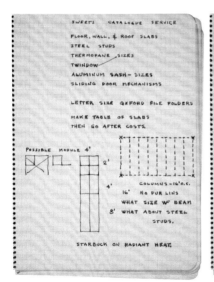

Tony Smith, Sketchbook #69, ca. 1950, each page 10⅜ × 8 in. (26.4 × 20.3 cm)

The Olsen House

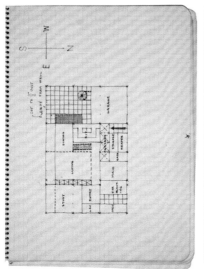

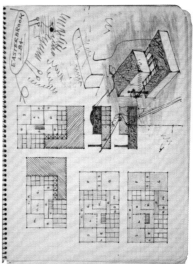

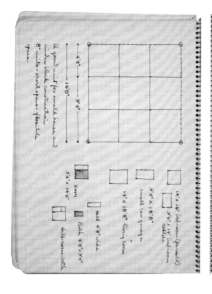

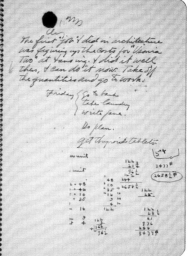

OLIN INDUSTRIES, INC.
505 PARK AVENUE
NEW YORK 22, NEW YORK

March 23, 1954

Mr. Tony Smith
Sportparkspr. 20
Nurnberg, Germany

Dear Tony:

I have intended sending you pictures of the house in
its present state of approximate completion, but I
have been traveling so much that I just haven't had
the opportunity to set down and write personal letters.
I have been also hesitant in starting this letter
because there are several things I want to ask you but
I am not at all sure I still have my mind made up
about just what are the things that are now bothering us.

First of all, let me make the overall statement that the
house in its totality is beautiful to a degree that
retains its stronghold upon our affection and enthusiasm.
I feel sure you can be satisfied that aesthetically there
is no finer house anywhere. I mean this with full
sincerity and with complete cognizance of some of the
difficulties that we are still experiencing. It is about
these difficulties that I now wish to talk to you.

The main house has had a series of leaking roofs in spite
of the fact that the roof was taken off and rebuilt by
the Barrett people last summer. By this I mean that the
Barrett Company sent its engineer and counselled with
Rivolta's sub-contractor. It got so bad that the water
was dripping freely on my bed unless I moved it, and the
ceiling cracked and quite a bit of the plaster fell down.
This winter the leak started again at the same place,
running parallel to the stonewall and in an exact line
along my bed and into the bathroom where it leaked down
through the tile at the place where the towel rail is
fastened in the ceiling.

Rivolta has endeavored to correct this during the past
week by putting two vents under the overhang, with the
idea of getting circulation in the space above the glass
wool. The current theory is that moisture is condensing

Fred Olsen Sr. letter to Tony Smith, March 23, 1954

against the cold roof, and especially in very cold
weather is freezing there, later thawing out and
falling through the glass wool installation. I am
hoping this is now corrected but I thought I would
like your slant on it. All of the windows have been
weather stripped, and after a second go-around
apparently the house is tight.

The floor in the living room cracked rather badly,
and there is at present about a 1/4-1/2" lower part
on one side of the crack. I do not know whether the
floor sank or part of it raised. The last couple of
weeks it has further cracked near the southwest corner
of the house. I am proposing to have the floor re-
finished either by grinding or by resurfacing. We are
going to carpet the bedroom because we keep it at a
cooler temperature and the floor is not pleasant and
comfortable under foot. Otherwise the main house is,
I think, completely satisfactory.

Incidentally, there are no complaints about the guest
house at all. It has remained entirely satisfactory.

The problem in the studio has been leaks at the windows
in spite of weather stripping and even calking, and you
may notice from the photograph that we inserted a very
small copper trough into the plaster below the window
which keeps the rain from slewing down the window and
ruining the grass below. It was actually washing out
a gully there.

Rivolta's men did not know how to build the overhang
for the west window, so I settled by putting plain
sandalwood colored glass fiber draperies up, which
effectively cut out the excessive light, and adds
considerably to the warmth. They also look very nice.

Enough cracks developed in the main concrete slab to
allow considerable leakage to come into the car port
and basement. We calked these and I have given the
whole slab a coating with one of the new synthetic
resins, which is alleged to waterproof the concrete.
It is doing a fair job and I expect one or two more
treatments will correct that. *There is no pitch on the slab so water
has to be brushed off the several lower shots after each rain.*
One change we have made, which unfortunately I have no
recent photographs to show, consists of a wall of
plexiglass which follows the overhang from the south
side of the door to our main house across the slab, and
then follows the edge of the slab around to the studio.
This was necessary because the prevailing southwest

winds became so unpleasant that we lost the use
of the deck for several months in which the weather
would have permitted outdoor living were it not for the
breezes being too strong and too cold. The wall is in
the form of carefully made redwood frames which are
held in place by brackets both on the ceiling and on the
floor. So far they have stood up under 65 mile winds,
but it is our intention to take all or part of them down
as the weather gets warmer.

The pool turned out to be a true delight. It is sea
water and I filter it continuously so that it is crystal
clear. I have put in a heater and actually used the
pool up to Christmas. I am going to start heating it
next week, and expect to use it from April to December.
This adds to the outdoor use of the house by several months.
Last summer Mrs. Olsen and I practically lived on the deck,
as we call the slab between the pool and the studio; cooked
most of our meals on a portable grill out there and en-
joyed it thoroughly.

Now we find our plans being changed for us. The Company
affairs have been radically altered, and we have established
a main office in New York, with the practical elimination
of my East Alton office. Consequently our Alton home
is no longer necessary, and we are trying to dispose of
it. This means that the Old Quarry house is now the
main house, and we are embarrassed with many household
possessions that we are completely unwilling to dispose
of, although we will sell or give away all of our
Alton furniture. I need a very considerable additional
space for the storage of paintings, sculpture, etc.

Furthermore, we have a splendid cook, Mattie, towards
whom we feel very considerable obligation, and Mattie
and her husband have decided, upon closing the Alton
house, they want to come to Connecticut with us.
Since she is one of the finest cooks we have ever known,
she does contribute vastly to our personal comfort.

Now, I realize, Tony, this is suggesting a picture which
is as different as anything could be from the one I
originally described to you. Nevertheless I am puzzling
about bringing to your attention what the problem is with
the idea that you may be able to think out some
solution, or at least a partial solution. We can get a
small house for Mattie and her husband somewhere between

Leete's Island and Guilford, and Mattie can drive to
Old Quarry and prepare luncheon and dinner for us, and
take care of the house while her husband does the outside
work, looks after the pool, etc. Mattie weighs 300 pounds,
plus, and with her red bandanna would make the finest Aunt
Jemima you ever saw.

If Mattie cooks in the main house kitchen there is no
room for Florence and myself other than to move into the
studio, and this may be a solution. On the other hand, if
Mattie cooks in the studio, leaving us alone in our own
little house, there just is not room in the small kitchen we
alloted. I am wondering if we could push the east wall of
the studio kitchen out to the position of the south door
of the studio and give at least double the present kitchen
space, which would probably permit smooth operation.

Actually the use of the studio has changed a great deal,
although much painting was done in it this last summer.
Several visiting artists include Hans Moller who spent
about 5 weeks with us, and they have found the place not
only highly congenial but also a very beautiful working
space. The light was too strong so we put split bamboo
vertical curtains in the west clear story window panels.
Some of Freddie's radio engineer friends have designed
a high fidelity phonograph system, which is so good that
we are using the studio more as a meeting place and as
a place to listen to music and watch movies, Kodak slides,
and I regret to say even television.

The thought therefore comes that let's use this as a very
beautiful sitting room and meeting room, and I am wondering
therefore if we could close in the space for a studio and
work shop in the north bay of the studio which would of
course destroy the effect of the free volume below the studio
but which would give a very fine additional volume for work
space and cupboards.

There is even the thought that space which is now car port
might be glassed in and connected to usable inside space,
moving the car storage down to a garage which I might build
jointly with Ralph Kirkpatrick on the junction of his lot
and ours on the west side of the road.

I wish I could talk these things out with you because very
frankly I am not completely sure we know finally what we want.
We are just conscious of a condition of mild frustration
in being faced with the problems that come from this switch
in the Company plans.

I would appreciate it if you would just think out
loud and be quite frank in your reactions.

Sincerely,

Fred Olsen
Vice President for
FO:dt Research and Development

Nürnberg,
Sportparkstr. 20
April 26, 1954

Dear Dr. Olsen:-

Thankyou for your considerate letter and superb photographs.
With all the trouble you have had and the explosives at hand your
restraint is noble. But I am glad that despite its serious faults,
you have decided to make the place your permanent home.

When I received your letter I thought that some solutions would
suggest themselves, and that I could send them along at once. So
instead of simply acknowledging your letter I started to think about
the problems. The latter proved rather confusing, and even at this
late date I have no simple and clear ideas.

Space seems to be required for four distinct uses: garage, stor-
age, studio, and Kitchen. Since for the last named I have only one
suggestion, I shall take that up first. While reading about it I
leapt ahead a little. You say, "I am wondering if we could push the
east wall of the studio kitchen out to..," and before I read what
follows, I had pushed it out to the line of the clerestory windows,
or, put in another way, enclosed the remaining space under the upper
roof. This would at least partially limit the way in and out of the
studio (and shower room). But it would make a calm and clear division
of the available space, and, I think, an almost celestially open and
capacious kitchen, one worthy of Mattie. I am not yet sure how the
internal arrangement would work out; but, for one thing, perhaps the
refrigerator, and some closet space, could be let into the present
little kitchen, and the remainder of that space could be used as a
cloak room or dressing room.

For the other area as required I can see four possibilities:
1). Build a new garage with Mr. Kirkpatrick, and use the present
car shelter for studio and storage space.
2). Build a new garage etc., and use the present car shelter for
storage and enclose a studio space under the present studio.

Tony Smith letter to Fred Olsen Sr., April 26, 1954

3). 3). Leave the present car shelter as it is; enclose a studio space under the present studio; build a storage space separate from the house (possibly in combination with a garage space for Mr. Kirkpatrick).

4). Leave the present car shelter as it is; build a new unit consisting of studio and storage space (again possibly in combination with a garage space for Mr. Kirkpatrick).

Taking the first of these suggestions, and assuming that building a garage down on the property line will present no problems. It should be easy to enclose the space now used for the cars, and I have made some sketches that assure me that it could be done handsomely as well. A partition could be built parallel to the wall of the heater room to enclose a storage space; the remainder enclosed with glass would be studio. Perhaps this solution requires the fewest moves, is simplest and most direct However, I think there are some positive disadvantages. The most serious is the possibility of the slab leaking. This seems particularly bad in relation to a storage space because a lot of damage could be done before you remove everything to make the repair. Then along the same line, the storage area might be damp due to its recessed position and lack of either sunlight or ventilation. Since the work space would be at the outside it would be less likely to be damp. On the other hand it would have a low ceiling and not too much light.

There is at least one more aspect to this scheme. When I first went to Leete's Island, I didn't realize it was your intention to build a car shelter at the house itself, or even a road to it. I thought you wanted to keep the place isolated and to leave the cars at the turnaround. I now think that the present arrangement is more practical. The convenience of being able to drive up to and into the house is considerable. This must be especially true at night, in bad weather, when things have to be brought in or out, for the arrival of guests who may not know their way around, during any kind of emergency, and when you just don't feel like walking. The fact that the drive has been established and the habit formed has some bearing. Not that you are particularly bound by habit. But my reaction is that it would be better all the way 'round to leave the car shelter somewhere near the house.

For the above reasons, in spite of its being easy to accomplish and the probability of its looking well, I am not keen on this solution.

3). The second possibility has some advantages. The floor of a space enclosed under the present studio could be put in at a lower level than that of the carport, thus creating greater ceiling height and better light. This could also be a rather pleasant room. There would be some sunlight from and a view towards the west. It would probably be dry and could be well ventilated. Heating pipes could be installed under the new floor; and it would make the room above more comfortable in cold weather. I don't think I could enclose it as nicely as I could enclose the carport alone. But by putting in sheets of glass (like those in store windows) inside the columns, the new part would not be too chaotic, and the present studio would still seem to "float" above.

By using the entire present carport for storage, this space could at least be well ventilated, and the things stored so placed as to avoid excessive dampness or probable damage from leaks.

But since the storage space might still be far from ideal, and since the ideas about the car shelter still hold, the third arrangement might be considered: that of leaving the carport as is, and building a little storage house (possibly in connection with a garage for Mr. Kirkpatrick). The advantages of putting the new studio under the old would still obtain; the carport would still be used to its present purpose, and a reliable storage space would be created. I can't find any serious practical objections to this plan; at the same time I am not in love with it. I cannot see closing the space under the present studio as easily as I can see enclosing the present car shelter, or the space I suggest for the kitchen. I do think it would be a nice enough room. I don't think it would look so well from the outside. However, my main objection is rather abstract: it is that I don't like the idea of closing that volumn. Please don't think I am trying to put this too strongly. I am only trying to make my feeling about it clear.

The last scheme, and the one I prefer, is to build a combination storage space and studio, "an ivory tower." Since I have always favored discrete buildings to additions, it is astonishing that a couple of weeks went by before I thought of this even as a possibility. The mere consideration of this approach brings up to a more acute degree your own preferences. For instance would you want to be so far from the main house? Practical questions. Heating it, and heating it fast. Water supply? And then what about Mr. Kirkpatrick? What about the As-

The above is a digest of what I have been thinking about. There are other factors, some rather vague. But this is already long overdue, and I can't think that the other factors are worth your time at the present, or at least until I can be clearer about them myself.

While I have not mentioned them in this letter, I have thought a great deal about the faults with the place as it is. However, my thoughts have produced consternation rather than any very practical solutions up to the present. I have put whatever ideas I have had down on paper, and I shall send them along after this. I shall send also at least one version of a combination building, so you can at least see how I have been visualizing it myself. I shall write to Mrs. Olsen separately. Thankyou again for the pictures (they were fine shock absorbers), and our best regards to you and all the family

Sincerely,

Contributors

Mario Gooden is a cultural practice architect and director of Mario Gooden Studio: Architecture + Design. His practice engages the cultural landscape and intersectionality of architecture, race, gender, sexuality, and technology. His work crosses the thresholds between the design of architecture and the built environment, writing, research, and performance. Gooden is also Professor of Practice at the Graduate School of Architecture, Planning and Preservation of Columbia University, where he is the Director of the Master of Architecture program and codirector of the Global Africa Lab. He is a 2012 National Endowment for the Arts Fellow, a MacDowell Fellow, and a 2019 recipient of the National Academy of Arts and Letters Award in Architecture. Gooden is the author of *Dark Space: Architecture, Representation, Black Identity* (Columbia University Press, 2016) as well as numerous essays and articles on architecture, art, and cultural production. He is Research Associate at Visual Identities in Art and Design at the University of Johannesburg and a founding board member of the Black Reconstruction Collective. Gooden graduated magna cum laude from Clemson University in 1987 with a BS in design, and received an MArch from Columbia University in 1990. His work has been exhibited nationally and internationally, including at the International Exhibition of Architecture Biennale, Venice; Architekturmuseum der TUM, Munich; Netherlands Architecture Institute; Storefront for Art and Architecture and the Municipal Art Society, New York; National Building Museum, Washington, DC; and the Museum of Modern Art, New York.

Christopher Ketcham is an art historian, writer, and teacher based in Massachusetts. His research focuses on the urban history of postwar American art and has been published in the *European Journal of American Culture*, *Public Art Dialogue*, and elsewhere. He has taught at Massachusetts College of Art and Design, Massachusetts Institute of Technology, and Tufts University.

Marta Kuzma is Professor of Art at the Yale School of Art, where she served as Dean in 2016–21. Previously, she was Chancellor of the Royal Institute of Art in Stockholm, Director of the Office for Contemporary Art Norway, and founding Director of the Soros Center for Contemporary Art in Kyiv. Earlier in her professional career, she was Artistic Director of the Washington Project for the Arts in Washington, DC, and head of the international exhibitions program at the

International Center of Photography in New York City. A member of the curatorial team for dOCUMENTA (13), Kuzma has curated many international exhibitions and research initiatives and authored numerous publications—most recently, *History of an Art School* (Walther König, 2022). Kuzma has been a visiting Professor in Art Theory in the Graduate Program of Visual Arts, University of Architecture (Iuav), in Venice. She received a postgraduate degree in aesthetics and art theory from the Centre for Research in Modern European Philosophy in London, and completed her undergraduate studies at Barnard College in New York City.

Peter L'Official is a writer, arts critic, and associate professor in literature and director of the American and Indigenous Studies Program at Bard College. He is the author of *Urban Legends: The South Bronx in Representation and Ruin* (Harvard University Press, 2020). His writing has appeared in *Architectural Record*, *Artforum*, *The Believer*, *Los Angeles Review of Books*, *The New Yorker*, *Paris Review Daily*, *Village Voice*, and other publications, and he is on the editorial board of the *European Review of Books*. His next book project will explore the intersections of literature, architecture, visual art, and Blackness in America.

R. H. Quaytman is an American/Irish artist who lives and works in Guilford, Connecticut. She studied at Bard College and the Institut des hautes études en arts plastiques in Paris, and received the Rome Prize from the American Academy in 2001. In 2015, Quaytman was awarded the Wolfgang Hahn Prize with Michael Krebber, and in 2022 was awarded the Charles Flint Kellogg Award in Arts and Letters from Bard College. Quaytman's works have been featured in documenta 14, the 54th Venice Biennale, and the 2010 Whitney Biennial. Solo shows have taken place at the Glenstone Museum, Potomac, MD; WIELS, Brussels; Solomon R. Guggenheim Museum, New York City; Secession, Vienna; Museum of Contemporary Art, Los Angeles; Tel Aviv Museum of Art; and the Renaissance Society, Chicago, among other venues.

Jas Rault is Associate Professor of Media Studies in the department of Arts, Culture, Media at University of Toronto Scarborough, and the Faculty of Information at University of Toronto. Rault's research focuses on mediations of gender, race, and sexuality in architecture and design, digital cultures and economies, and arts and social movements. This includes publications on the confluence between "coloniality, digitality and architectural modernity" (*American Quarterly*), "White Noise/White Affects" in queer popular culture (*Feminist Media Studies*), "'Ridiculizing' Power: *Relajo* and the Affects of Queer Activism in Mexico" (*Scholar & Feminist Online*), risk and intimate networks in queer digital archives (*Women & Performance*), and more, in such journals as *Ada*, *Archives of American Art*, *Ephemera*, *Interiors: Design, Architecture, Culture*, and *Women's Studies Quarterly*. Their first book, *Eileen Gray and the Design of Sapphic Modernity: Staying In*, was published by Routledge in 2011, and their second book, *Heavy Processing*, co-authored with T.L. Cowan, will be published by Punctum Books. Rault is codirector of Digital Research Ethics Collaboratory (DREC, drecollab. org) and Cabaret Commons (cabaret-commons.org).

Acknowledgments

Against Reason: Tony Smith, Architecture, and Other Modernisms is the companion book to *Tony Smith: Architecture Catalogue Raisonné*. This dual publication comprises half of the Tony Smith Catalogue Raisonné Project (the other two volumes being dedicated to Smith's sculpture). The two *Against Reason* books occupy a unique place in an ambitious multivolume project because the contributors have decisively referred to and creatively drawn from the archive—including published and unpublished work on and around Smith—to produce new and inspiring knowledge about the artist and the era in which he worked. Their contributions, all specially commissioned for this book, combined with the three other books published as part of the catalogue raisonné project are the most concentrated collection to date of writings and work related to Smith's legacy. I am grateful to Mario Gooden, Christopher Ketcham, Marta Kuzma, Peter L'Official, R. H. Quatyman, and Jas Rault for their time and attention, not to mention their intelligence, creativity, and collaboration offered throughout the process of working on this book.

As with all edited publications, this book is indebted to a network of individuals. I am thankful to Victoria Hindley, senior acquisitions editor at the MIT Press, for her support of the Tony Smith Catalogue Raisonné Project—and of the *Against Reason* project in particular, which, as a unique approach to a catalogue raisonné, has benefited from her expert guidance. The MIT Press and its knowledgeable team, especially Matthew Abbate, have been essential in bringing this book to completion. The organization was aided by peer reviewers, whose reflections and recommendations positively impacted the final volume presented here.

I am grateful to the Tony Smith Catalogue Raisonné team, without whose focus on the research and assembly of our publication project *Against Reason* would not have been possible. My coeditor on the catalogue raisonné volumes—Sarah Auld, Director of the Tony Smith Estate—has an extraordinarily vast knowledge about Tony Smith and his work, and I am grateful to her for our close communication about the *Against Reason* books and working with her on the project overall. Research associate Susannah Faber's attention to *Against Reason*— her patience and keen ability to organize and manage the photography and permissions—was instrumental to making this book and the others a reality.

The team for this book also includes our copy editor, John Ewing. His thoughtfulness and expertise applied to every aspect of the book, and to the project as a whole, have been instrumental. I am grateful for his collaboration. We are deeply indebted to James Goggin and Shan James of Practise, whose design expertise and editorial adeptness have fostered a true partnership on each book in the publication project.

Against Reason: Tony Smith, Architecture, and Other Modernisms, like the other three books comprising the Tony Smith Catalogue Raisonné Project, is indebted to the late Jane Smith, whose commitment to the legacy of her husband provided the groundwork for the Tony Smith Foundation, the institution that has served as the main organizing arm supporting this research. The TSF board—Kiki Smith, Seton Smith, Antonia Dean, and Jeffrey Peabody—have shepherded these books every step of the way, helping ensure their art historical and biographical accuracy.

As an art historian and curator of modern and contemporary art, I am fortunate to have the opportunity, indeed pleasure, to work with and think about the complexities inherent in Tony Smith's rich bodies of work, and the intersections his architecture and sculpture practices made with other disciplines. In many ways, we have only begun to explore Tony Smith's impact on the history of art and the work of contemporary practitioners—which, as *Against Reason* attests, continues to resonate today.

James Voorhies
Editor

Photography Credits

Courtesy Anthony and Johann Bultman, p. 98

Photo Andrew Bush, pp. 102, 111

Cambridge University Press, 1961, reproduced with permission of the Licensor through PLSclear, pp. 22, 24, 131

Jerry Cooke, p. 69

Courtesy Fisher Arts Library Image Collection, n2017040104, copyright provided by Architectural Archives, University of Pennsylvania, p. 72

© 2025 by David Gahr, courtesy Gahrchive Inc., pp. 79–80

Courtesy Fred Olsen IV, photo Hans Namuth, p. 145

Courtesy R. H. Quaytman, pp. 122 (top), 124–25, 132, 134 (left)–135 (left), 140–41, 143–44, 146–52, 155–59, 162

Photo David H. Sargent, p. 142

Courtesy Tony Smith Archives, pp. 27, 30–31, 40, 46–47, 52, 54–55, 60–61, 71, 86–88, 99, 103, 123, 163, 165, 168–74, 177–85; photo Rudy Burckhardt, p. 78; photo Bill Cunningham, p. 164; photo

Jon Naar, pp. 112–13, 115; photo Chas. R. Pearson, p. 27; photo Edward Saxon, p. 70

Courtesy Tony Smith Estate, pp. 23, 26, 33–38, 49–51, 55, 68, 122 (bottom), 124 (bottom left), 125–30, 133–39, 154, 160–61, 166–67, 175–76

Front cover: detail from Fred Olsen Sr. House, 1951–53, site plan, blackprint, 14¼ × 16⅞ in. (36.2 × 42.9 cm), courtesy Tony Smith Estate

Inside front cover: L. L. Brotherton House, 1944–45, courtesy Tony Smith Archives, photo P. A. Dearborn

First inside page: detail from Sketchbook #68, 1950, 10⅜ × 8 in. (26.4 × 20.3 cm), courtesy Tony Smith Estate

Second inside page: model for *Mountain Piece*, 1968, earthwork, cut projected at 1,400 ft. across on 45,000-acre property (unrealized), courtesy Tony Smith Archives

Inside back cover: Smith van Fossen, *L. L. Brotherton House*, 1944–45, graphite on tracing paper, 17⅝ × 23½ in. (44.8 × 59.7 cm)

Back cover: Theodoros Stamos House, 1951, courtesy Tony Smith Archives, photo Andrew Bush

**Against Reason: Tony Smith,
Architecture, and Other Modernisms
Volume 2**

Editor: James Voorhies
Photography Rights, Reproductions,
 and Research: Susannah Faber,
 Mae Stark
Copy Editor: John Ewing
Research Advisor: Sarah Auld

Design: James Goggin and
 Shan James, Practise
Lithography: Colour & Books